MOTHER AND CHILD CARE IN ART

Alan EH Emery and
Marcia LH Emery

Foreword by

Sir John Hanson

MOTHER AND CHILD CARE
IN ART

Alan EH Emery and
Marcia LH Emery

Foreword by

Sir John Hanson

The ROYAL
SOCIETY *of*
MEDICINE
PRESS *Limited*

The Royal College of
Midwives

Royal College
of Physicians

Setting higher medical standards

© 2007 Royal Society of Medicine Press Ltd
Published by the Royal Society of Medicine Press Ltd
1 Wimpole Street, London W1G 0AE, UK
Tel: +44 (0)20 7290 2921
Fax: +44 (0)20 7290 2929
E-mail: publishing@rsm.ac.uk
Website: www.rsmpress.co.uk

British Library Cataloguing in Publication Data
A catalogue record for this book is available from the British Library

ISBN 1-85315-629-9

Distribution in Europe and Rest of World:

Marston Book Services Ltd
PO Box 269
Abingdon
Oxon OX14 4YN, UK
Tel: +44 (0)1235 465500
Fax: +44 (0)1235 465555
Email: direct.order@marston.co.uk

Distribution in the USA and Canada:

Royal Society of Medicine Press Ltd
c/o BookMasters, Inc.
30 Amberwood Parkway
Ashland, Ohio 44805, USA
Tel: +1 800 247 6553/ +1 800 266 5564
Fax: +1 419 281 6883
Email: order@bookmasters.com

Distribution in Australia and New Zealand:

Elsevier Australia
30–52 Smidmore Street
Marrikville NSW 2204, Australia
Tel: +61 2 9349 5811
Fax: +61 2 9349 5911
Email: service@elsevier.com.au

Typeset by Phoenix Photosetting, Chatham, Kent

Printed and bound by Alfabase

CONTENTS

FOREWORD

This new volume by Alan and Marcia Emery supplies the third part of their richly embroidered trilogy on medicine and art. It is a broad canvas of themes and threads and sometimes breathtaking illustration – look only at Otto Dix's striking *Newborn Baby on Hands* which provides the front cover. From within the whole content their narrative contribution to the history of medicine now emerges with clarity and warmth, fed by their distinctive insight into the artist's eye and – of special interest in this third composition – affording the reader an occasional restrained glimpse of the authors' own stand point in moral observation. While that may be a description from which Alan and Marcia would naturally shy away, few scientists and no artists would wish to claim that their production was values-free. Nor should it be.

The focus on *Mother and Child Care in Art* is practical and empirical rather than spiritual or metaphysical. Although the second volume was published recently in 2005, the authors' project is not a-book-a-year but reflects a lifetime's interest and study. It proceeds with a consistent historical perspective. The earlier two volumes dealt with the evolution of the roles of physician and surgeon over centuries. Now it is the turn of paediatrics and obstetrics. While essays 1 (*Cutting Corn in Ancient Egypt*) and 3 (*Presentation of the Fetus in Utero*) remind us that obstetrics goes back to the ancient world, the Emerys' text and choice of plates adds the corrective that the keys to real progress as a speciality were major advances in anaesthetics and countering infection in modern times. Given the persistent early traditions which depicted children as miniature adults, we should be less surprised at the apparent neglect of paediatrics in ancient and medieval practice. Plate 58 (*Incubators' at the Maternity Hospital, Port Royal, Paris*) points out the early importance in its development of care of the newly born and is a fascinating link with the history and significance of nurses' training.

History of art or the history of medicine, then? Both of course, but this is also a book about the changing history of mankind: behaviour to man, about human sensitivity, compassion and dignity. Read first essay 25 (*Faces*), the moving story of the talented and admirable Alison Lapper. Then essays 54 (Joan Eardley's *A Glasgow Close*) and 57 (Paula Rego's disturbing and powerful *The Family*). Rather differently, essay 67 (*Medical Genetics in the Prevention of Handicap*), the last chapter in the book, looks ahead and links with Alan's career-long interest in human genetics and disease. Green College Fellows congratulate Alan and Marcia Emery on this beautiful and illuminating addition to their joint work on medicine and art.

Sir John Hanson KCMG CBE MA
Warden, Green College, Oxford, 2006

ACKNOWLEDGEMENTS

It is a particular pleasure to acknowledge our gratitude to all the various individuals and organizations who have kindly granted us permission to reproduce the works of art in this volume, many of whom also provided images for reproduction. These have been formally acknowledged with each illustration.

Special thanks are due to Dr Robert Allan (Editor of *Clinical Medicine*), Diana Beaven (Publication Manager) and Johanna Tootell of the Royal College of Physicians of London for their encouragement and help.

There are a number of others who have also been particularly helpful. They include Sir Alan Craft (President, Royal College of Paediatrics and Child Health), Sir Roy Calne (Cambridge), Professor Michael Connor (Duncan Guthrie Institute of Medical Genetics, Glasgow), Dr Beryl Corner, Dr Geoffrey Farrer-Brown (A Picture of Health Ltd.), Euan Mackay and Angus Mackay (Pulborough), Dr Nigel Strudwick, Helen Robbins and Jennifer Ramkalawon (British Museum), Lisa A Mix (Archives and Special Collections, University of California at San Francisco), Monique Cohen (Bibliothèque Nationale de France), Silke Pirolt (Österreichische National Bibliothek), Barbara Sicko (Bob Jones University, Greenville, South Carolina), Thomas Hunter (Onondaga Historical Association, Syracuse, New York), Venita Paul (Wellcome Library, London), John Rockwell (Antrim, New Hampshire), Julian Abraham (Quaker Tapestry, Kendal), Anne Dulau (Hunterian Museum and Art Gallery, Glasgow), Laura Travis (Dittrick Medical History Center, Case Western Reserve University, Cleveland, Ohio) and Bill Hopkins (Department of Medical Illustration, Edinburgh University).

We owe a particular debt of gratitude to Peter Richardson (Managing Director), and Ian Jones of the Royal Society of Medicine Press and their colleagues, particularly Mark Sanderson for the production of the volume, and Hannah Wessely and Laura Compton for their professional help and advice in all aspects of editing and obtaining permissions. Their enthusiasm and professionalism have been a great inspiration.

Finally, we are most grateful to the Warden, Sir John Hanson, and the Fellows of Green College, Oxford for providing facilities for researching and writing the book.

Oxford, 2006

INTRODUCTION

'Past sorrows, let us moderately lament them,
For those to come, seek wisely to prevent them.'

John Webster, *The Duchess of Malfi* (c 1612)

'Fine art is that in which the hand, the head, and the heart of man go together.'

John Ruskin, *The Two Paths* (1859)

'Science and medicine are largely learned,
Art is largely heaven sent.'

When researching material for this book, we were astonished by the number of works of art depicting mother and child care. Many of the finest representations of the mother–child relationship in the Renaissance are concerned with the Holy Family. Although these are acknowledged as great masterpieces in their own right, we have concentrated largely on works that are not devotional. Furthermore, in many cases, we have attempted to arrange them roughly in the chronological order of the events depicted rather than according to the dates they were created, particularly in regard to obstetrics. Some topics, however, such as childhood infections, birth defects and scientific developments, have been grouped together.

Two sources have been especially valuable in tracing early developments: Nunn's study of Ancient Egyptian medicine[1] and Phillips' text on Ancient Greek medicine.[2] Both are highly readable and well documented.

When we come to accounts of the history of the subject, three recent sources dealing specifically with obstetrics and paediatrics have been helpful,[3–5] while others have been of more general importance.[6–8] Writers have occasionally also considered certain aspects of the subject in works of art.[9–15] With one or two exceptions, included for their wider significance, we have excluded depictions of maternal or childhood diseases in art, a subject which has been reviewed elsewhere,[16–20] including a very detailed study of dwarfism.[21]

Our selection of works concerned with maternal and child care represents only a small fraction of those on the subject, and has been somewhat eclectic and inevitably influenced by our own personal preferences. We list other examples in a table at the end of the book.

Several of the essays mention various laboratory-based developments. Perhaps most important among these has been the setting up of cytogenetic and molecular genetic laboratories, stemming largely from advances in medical genetics over the last few decades. The implications for the diagnosis, management and treatment of disease are considerable. However, despite all the developments in medical technology, beginning with the introduction of the stethoscope in 1816, much of the decline in obstetric problems stems from the introduction of antisepsis and, in difficult cases, from the use of effective anaesthesia. In the case of childhood diseases it is clear that the reduction in infectious diseases was significantly affected by vaccination programmes, beginning with smallpox in 1798, as well as the much later introduction of antibiotics. But otherwise the greatest effect on both maternal and child health has resulted from education and improvements in the general standard of living, particularly in regard to better housing and nutrition.

Finally, the care and welfare of the mother and her child are inextricably linked, and their close relationship and dependency has been evident from earliest times to artists, writers and poets:

'So for the mother's sake the child was dear,
And dearer was the mother for the child.'

Samuel Taylor Coleridge, *Sonnet to a*
Friend on the Birth of his Infant Son (1796)

References

1. Nunn JF. *Ancient Egyptian Medicine*. London: British Museum Press, 1996.
2. Phillips ED. *Aspects of Greek Medicine*. London and Sydney: Croom Helm, 1987.
3. O'Dowd MJ, Philipp EE. *The History of Obstetrics and Gynaecology*. New York and London: Parthenon, 1994.
4. Loudon I. *The Tragedy of Childbed Fever*. Oxford: Oxford University Press, 2000.
5. Colon AR, Colon PA. *Nurturing Children – A History of Pediatrics*. Westport, Connecticut and London: Greenwood Press, 1999.
6. Kipple KF (ed). *The Cambridge World History of Disease*. Cambridge: Cambridge University Press, 1993.
7. Bynum WF, Porter R. *Companion Encyclopedia of the History of Medicine*. London and New York: Routledge, 1993.
8. Porter R. *The Greatest Benefit to Mankind*. London: Harper Collins, 1997.
9. Sigerist HE. The historical aspect of art and medicine. *Bull Inst Hist Med* 1936; **4**: 271–97.
10. Schlesinger BE. Paediatrics in classical art. *BMJ* 1962; **ii**: 1671–7.
11. van Dongen JA. *De zieke Mens in de Beeldende Kunst*. Amsterdam: De Bussy, 1968.
12. Brown C. *Scenes of Everyday Life: Dutch Genre Painting of the Seventeenth Century*. London and Boston: Faber & Faber, 1984.
13. Lash J. *Twins and the Double*. London: Thames & Hudson, 1993.
14. Howden-Chapman P, Mackenbach J. Poverty and painting: representations in 19th century Europe. *BMJ* 2002: **325**: 1502–5.
15. Hagen R-M, Hagen R. *What Great Paintings Say*. Cologne: Taschen, 2003.
16. Kunze J, Nippert I. *Genetics and Malformations in Art*. Berlin: Grosse Verlag, 1986.
17. Emery AEH. Medicine, genetics and art. *Proc R Coll Phys Edin* 1991; **21**: 33–42.
18. Enderle A, Meyerhöfer D, Unverfehrt G. *Small People – Great Art*. Hamm: Artcolor Verlag, 1994.
19. Emery AEH, Emery M. Genetics in art. *J Med Genet* 1994; **31**: 420–2.
20. Emery AEH. Genetic disorders in portraits. *Am J Med Genet* 1996; **66**: 334–9.
21. Dasen V. *Dwarfs in Ancient Egypt and Greece*. Oxford: Oxford University Press, 1993.

The Plates

1

Cutting Corn in Ancient Egypt (c 1250 BC)

anonymous, Burial Chamber of Sennedjem, Deir el-Medina, Luxor, Egypt

Herodotus, the Greek historian of the 5th century BC, commented that at the time, each Egyptian physician in his opinion '...treats a single disorder, and no more, thus the country swarms with medical practitioners, some undertaking to cure diseases of the eye, others of the head, others again of the teeth, other of the intestines, and some of those which are not local.' (*The Histories*, Book II, 84). But it is not entirely clear who practiced obstetrics, and the medical papyri do not refer in detail to normal labour. However, interest was clearly taken in the subject since in Ancient Egyptian papyri there are frequent references to the magical births of the pharaohs.

This scene taken from an Egyptian burial chamber (c. 1250 BC) shows a workman, Sennedjem, and his wife involved in various agricultural tasks, including cutting corn. In his excellent book *Ancient Egyptian Medicine* (British Museum Press, 1996), John Nunn refers to the Berlin papyrus, from which he quotes: 'Another test to see if a woman will bear a child or if she will not bear a child. Emmer (wheat) and barley, the lady should moisten with her urine every day If the barley grows it means a male. If emmer grows, it means a female. If they do not grow, she will not bear a child.'

Recent research does in fact indicate that the test seems to be a reasonable indicator of pregnancy, but does not exclude it. However, it does not accurately predict fetal sex. Tests for the accurate prediction of the sex and condition of the fetus would not be developed for another 3000 years.

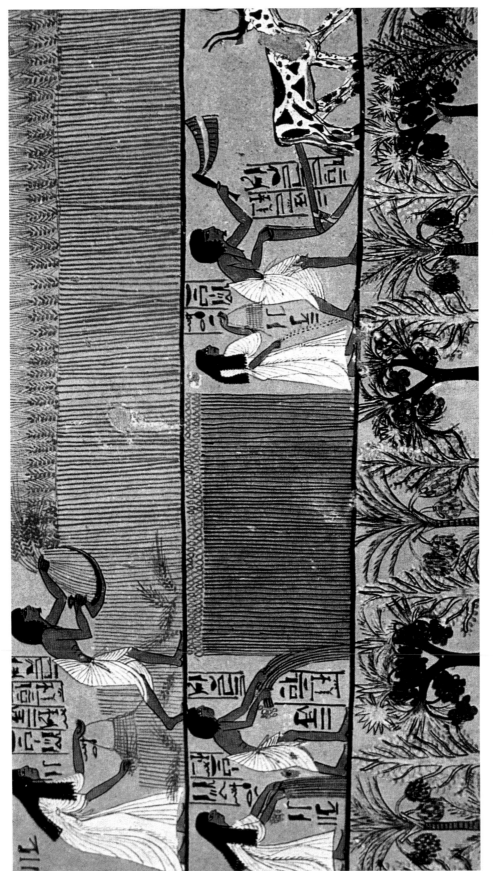

Cutting Corn in Ancient Egypt (c 1250 BC), anonymous. Burial Chamber of Sennedjem at Deir el-Medina, Luxor, Egypt. *Author's collection.*

2

Aristotle Contemplating a Bust of Homer (1653)

by Rembrandt van Rijn

There is no authentic representation of Aristotle. There is a statue to him in the Palazzo Spada in Rome, and he has been depicted in the wonderful *School of Athens* by Raphael. In this work, Rembrandt (1606–1669) has portrayed the philosopher as a man who was influenced by Homer, the epic poet. But he is best noted by scientists and the medical profession for his questioning approach to animal and human biology including heredity.

Aristotle (384–322 BC) was the son of a physician. He was born in Macedonia, but in his late teens moved to Athens, where he became a pupil of Plato for 20 years. He left a vast number of works on a great variety of subjects, including politics, logic, metaphysics, rhetoric and notably natural philosophy. In his *Historia Animalium*, he discusses in considerable detail the diverse manner in which animals reproduce. But it is in his *De Generatione Animalium* that we have more interest. His idea that the side on which a baby develops determines its sex (Book IV, 765) was widely held for generations. But of particular interest is his questioning of how offspring come to resemble their parents more than other individuals.

Aristotle believed (Book I, 721–723) that male and female 'semen' [sic] was formed from every part of the body of each parent and through sexual intercourse would mix and result in a child resembling its parents. But he noted that the resemblance of children to their parents is no proof that the 'semen' comes from the whole body, because resemblance can occur in voice, nails, hair and way of moving. He has clearly distinguished between what we might now consider hereditary and acquired characteristics. He also questioned how a child can sometimes resemble an antecedent more than a parent, or how to account for the occurrence of congenital abnormalities (Book IV, 769). Aristotle raised problems concerning heredity that would not be satisfactorily explained until the 20th century.

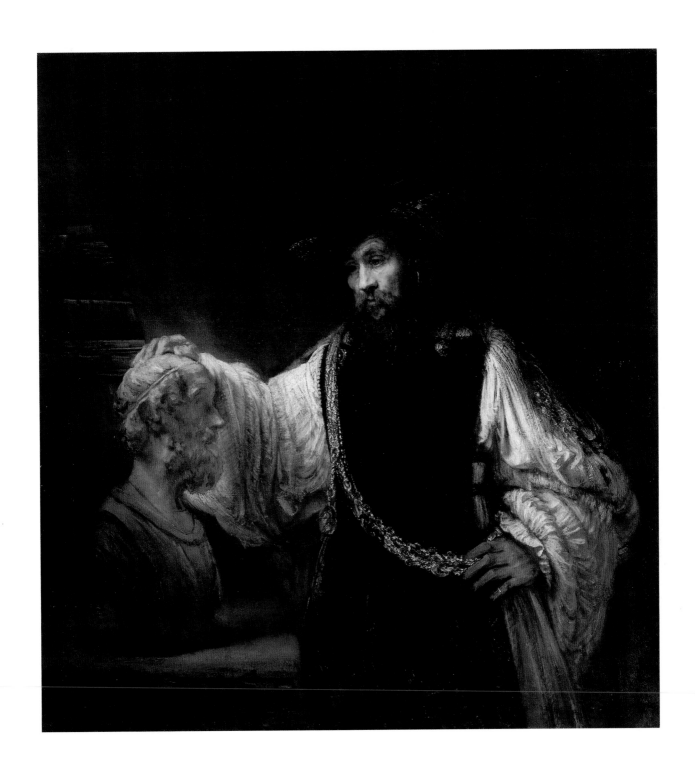

Aristotle Contemplating a Bust of Homer (1653) by Rembrandt van Rijn. Oil on canvas, 143.5 cm × 136.5 cm.
New York, The Metropolitan Museum of Art. Purchase, special contributions and funds given or bequeathed by friends of the Museum, 1961 (61.198).
© Photo 1995, The Metropolitan Museum of Art.

3

Presentation of the Fetus *in Utero* (9th–10th century)

anonymous, from Gynaikeia *by Soranus of Ephesus*

It must have been recognized from very early times that an unusual position of the fetus could present a serious problem for the delivery of a healthy child. Apart from the pain and suffering involved in the delivery, there could be a serious risk to the life of the child and the mother. Not featured in this illustration, but evident in many others, was the transverse lie. And there was also the problem of cephalopelvic disproportion. The only method for ensuring the delivery of a living infant in such serious situations would be Caesarean section, and before anaesthesia and the control of infection, this would not be an acceptable possibility for many years.

This illustration is taken from a 9th–10th century manuscript of a textbook by Soranus of Ephesus (AD 98–138), who appears to have been one of the very first to have documented turning the baby by inserting a hand into the uterus, clasping one or both feet (podalic) of the unborn child and turning it (version) in such a way that it could be delivered vaginally.

Instrumentation to assist delivery had been in existence from early times, but usually for extracting a dead infant. For example, if all else failed, instrumentation, such as the cranioclast and encephalotribe, could be used to perforate the fetal head and allow a dead infant to be extracted. Peter Chamberlen the Elder (1575–1628), who was born in Paris but immigrated to England, is credited with constructing an obstetric forceps, but the instruments were kept secret by the Chamberlen family for nearly 150 years. They were a clever invention: the two halves could be separated and inserted individually into the uterus and then brought together to hold the fetal head to aid extraction. Thereafter, many other varieties of obstetric forceps were developed, such as Smellie's and Kielland's, which continue to be used today, along, if indicated, with vacuum extractors, which may have been first used by James Young in 1705.

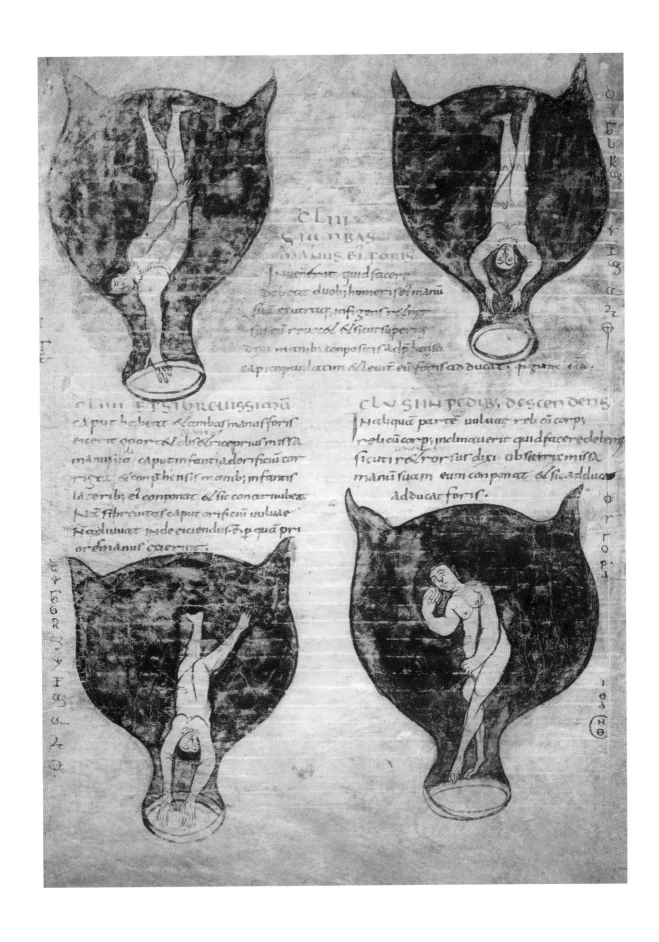

Presentation of the Fetus in Utero (9th–10th century), anonymous, from *Gynaikeia* by Soranus of Ephesus. Manuscript illustration, 28.3 cm × 19.4 cm. *Brussels, Bibliothèque royale de Belgique.*
© Bibliothèque royale de Belgique.

4

The Disease Woman (c 1420–1430)

anonymous, from the Wellcome Apocalypse

This illustration was probably produced in a monastic workshop, perhaps in Thuringia, Germany. It was most likely intended as an educational work for religious communities, who were often involved in the medical care of their colleagues as well as the local community, as indicated by this focus on women's medicine.

Our knowledge of human anatomy on which advances in surgery were dependent goes back to ancient Greece. Herophilus (c 350–280 BC) and Erasistratus (c 310–250 BC) are credited with being the first to study the anatomy of the human body from dissected corpses. Their writings, however, were largely lost, and it was another Greek, Galen (c AD 130–200), who contributed significantly to the subject. However, because by his time dissection had lost support from the authorities, most of Galen's work was based on animal studies. This led to errors that were to be perpetuated for many centuries, Galen's works being considered beyond reproach by his successors. Yet, several centuries later, the distinguished Arab surgeon Albucasis (AD 926–1013), then in Cordoba, concluded that surgery as a specialty had almost completely disappeared from Spain because of a lack of good and reliable anatomical knowledge.

Even in this illustration from a 15th century manuscript, the details of the structure of the human body were very superficial. It is meant to represent a female, but the uterus (labelled *embrio*) is positioned in the upper right of the abdomen far from the cervix, and the two kidneys are pushed to the outside by the intestines – and in fact their calyces are pointing outwards. The main purpose of the illustration, however, was the listing and localizing of different diseases, such as afflictions of the head (mania, inflamed eyes) and swelling of the feet. Few, however, could be considered specifically female disorders, except for obvious ones such as 'closed' womb.

Anatomy at this stage had really advanced very little and imposed serious limits on the understanding of diseases and surgical development.

According to the Wellcome Library, this work represents perhaps the high point of a tradition of medical illustration dating back to the 12th century. Thereafter, the advent of naturalism in the Renaissance consigned it to history.

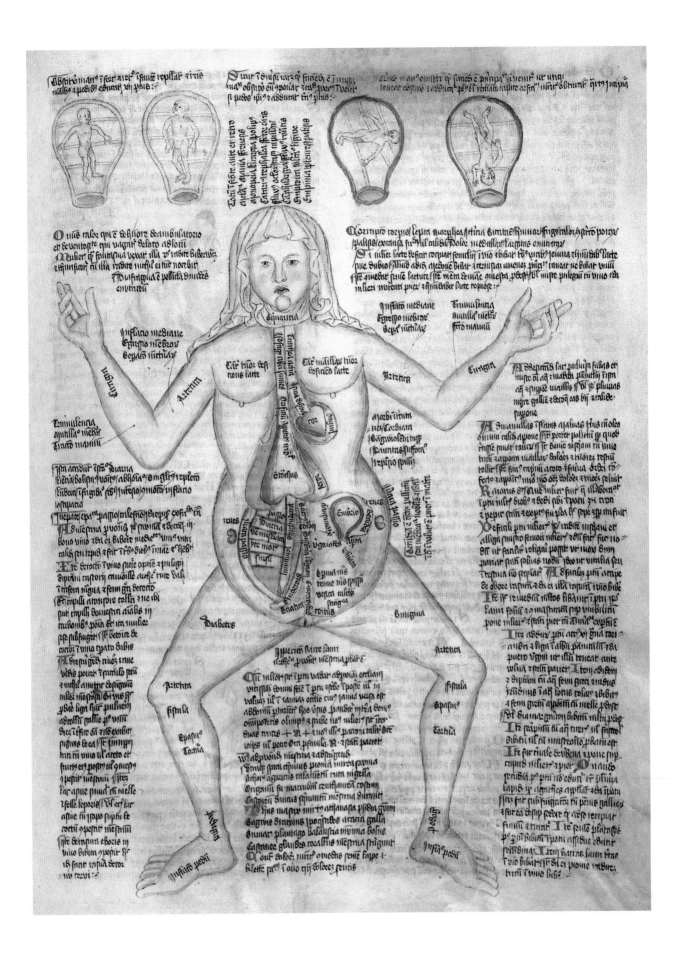

The Disease Woman (c 1420–1430) from the Wellcome Apocalypse. Brown ink on vellum, 400 cm × 300 cm. *London, Wellcome Library (MS 49, f. 38).*

5

Female Anatomy (1543)

wood engraving from De Humani Corporus Fabrica *by Andreas Vesalius*

There is no doubt that advances in understanding the anatomy of the human body, including the pregnant female, are indebted to the very major contributions of two anatomists of the 16th century: Leonardo da Vinci and Andreas Vesalius.

Restrictions on human dissection were gradually being relaxed, and it was at this time that Leonardo da Vinci (1452–1519) produced his sketchbooks, each based on his own 30 meticulous dissections. His *The Fetus in Utero* is renowned. The fetus, with breech presentation, lies curled in the uterus and is clearly in the later third trimester. Leonardo had no knowledge of the coverings of the fetus, and therefore illustrated their attachment by a stylized cotyledonous placenta as in ungulates. Furthermore, it is not entirely clear whether he understood how the ovary is connected to the uterus. Nevertheless, this was a considerable advance on previous studies of the pregnant uterus. Interestingly, Leonardo comments in a note by the illustration that there is no fetal heartbeat – perhaps a reflection of the then current notion that transmission of the soul only occurred at birth.

Andreas Vesalius (1514–1564) was born in Brussels of a well-known medical family. He went to Paris to study medicine. In 1537, he was appointed Professor of Surgery and Anatomy at Padua, and it was there that he produced his major anatomical work, *De Humani Corporis Fabrica* (*The Structure of the Human Body*), a copy of which is lodged in the library of the Royal Society of Medicine.

In the *Fabrica* (as it is often referred to) are detailed drawings of every structure of the human body. Here for example, Vesalius has removed the skin from the right breast to reveal the structure, and the stomach, spleen and intestines have been removed to reveal structures lying more posteriorly. The tubes carrying material from the testes (ovaries) to the uterus are revealed. He has also excised part of the pubic bones to show the neck of the uterus and the vagina. The anatomy of the generative organs is obvious, but details of reproduction and fertilization would only become clear in the 17th century.

It was the Dutch physician Reinier de Graaf (1641–1673) who first coined the word 'ovary' (previously referred to as testes, as in the male), and the Graafian follicles are named after him. He gave detailed accounts of both the female and male reproductive systems. Thereafter developed the *preformationist* controversy: some believed that a minute human body (a homunculus) resided in the ovum (ovists) or sperm (animaculists) and that this subsequently developed into a full organism. It was Wilhelm Hertwig in 1876 who observed that the spermatozoon entered the ovum and that fertilization occurs by the union of the nuclei of both male and female sex cells. This is a very far cry from Aristotle's idea that the male sperm fashioned menstrual blood into a human being!

Female Anatomy (1543) from *De Humani Corporus Fabrica*, by Andreas Vesalius. Wood engraving. *London, Royal Society of Medicine Library*.

6

From Conception to Delivery (1880)

by Yoshitora Utagawa

This delightful print of a Japanese coloured woodcut depicts a woman at monthly intervals during pregnancy. The artist of this triptych was Yoshitora Utagawa (fl 1850–1870). Neither the dates of his birth nor those of his death are known. He was born and worked in Edo, and was a pupil of the famous ukiyo-e artist Utagawa Kuniyoshi. Although the majority of his designs show conventional subjects – historical scenes and Japanese legends, beautiful women, warriors and actors – he was chiefly known for his Yokohama prints, or Yokohama-e, 'e' being Japanese for 'picture'. When Japan had to open the country to the West in the latter part of the 19th century, foreign merchants and diplomats were restricted to an enclave at the harbour of Yokohama. The Japanese had never seen foreigners before, and so there was a huge demand for prints depicting the foreigners and their hitherto unknown technical inventions such as iron ships, locomotives and hot air balloons. Many ukiyo-e artists of the time, including Yoshitora, became highly successful in this new genre of print.

With regard to this work, reading from right to left, we see how over time the mother's breasts enlarge as the fetus takes form. These changes are paralleled by the passing of the seasons symbolized by different flowers, from January to October. The position of the fetus in the gravid uterus changes from time to time but is finally shown in the cephalic position associated with a normal birth.

Although the text details embryological development, advances in our knowledge of the subject occurred over many years. In the 17th century, with the advent of microscopy, detailed studies of early development were pioneered by Marcello Malpighi (1628–1694), Professor of Medicine at Bologna. *Theoria Generationis* (1759), by Caspar Friedrich Wolff (1733–1794) of Berlin, is generally accepted as the starting point of modern embryology. He is eponymously remembered by his discovery of the Wolffian body and duct of the kidney. However, it was the subsequent establishment of the cell theory that placed embryology on a firm basis. The theory was proposed by Mathias Jacob Schleiden in regard to plants in 1838, and Theodor Schwann a year later applied it to animal tissues. The theory held that cells are the ultimate units of all living things. Others whose pioneering work established the science of embryology include von Baer, Rathke and Pander. But although the fundamentals of embryology were well established by the 20th century, the detailed molecular mechanisms involved in tissue differentiation and development remain significant challenges to present-day investigators. Stem cell research is an important by-product of this work, which may well lead to effective treatments for conditions such as diabetes and Parkinson's disease.

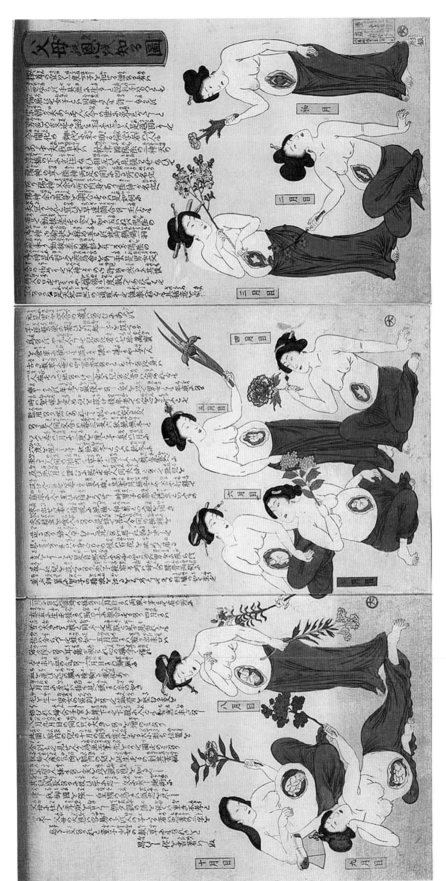

From Conception to Delivery (1880), by Yoshitora Utagawa. Coloured woodcut, 35.5 cm × 71.7 cm. San Francisco, University of California. Courtesy of Archives and Special Collections, Library and Center for Knowledge Management, University of California, San Francisco.

7

February (c 1416)

miniature by *The Limburg Brothers from* Les Très Riches Heures du Duc de Berry

The Limburg Brothers – Paul, Herman and Jean – are rightfully famous for their beautifully illuminated manuscripts, of which the Book of Hours – *Les Très Riches Heures du Duc de Berry* – is the most celebrated. Their great patron at the time was the Duc de Berry, and the three brothers lived in the Duke's capital city of Bourges. The Book of Hours contained pages for each hour of the day, and each month has its own picture recording contemporary life. Yet before they could complete it, all three brothers died suddenly in the spring of 1416, perhaps in an epidemic of influenza or cholera.

Apart from the more affluent levels of society, most married women in the past not only had the responsibility of caring for their children and the home but were also required to work alongside their menfolk. In this detailed miniature, we have a very good record of what their lives might have been like in the Middle Ages.

The three individuals in this illustration from February, the coldest month, have lifted their skirts to warm themselves at the fire. The genitalia of two of them are exposed, but at the time this would not have been considered out of the ordinary, and in any event women's underwear did not come into use for another 300 years. Also, cramped living space made privacy difficult. Incidentally, the snow landscape is one of the earliest in art. At the time, winters could be extreme and harvests were subsequently affected. Starvation was never far away.

Epidemics of infectious diseases were not uncommon, and date back, for example, to the plagues of possibly influenza in Athens in 430 BC and probably bubonic in Rome in around AD 542, which lasted intermittently for more than 50 years. At the time when this miniature was painted, Europe had been ravaged by the Black Death from 1348. Society was still suffering the social consequences of having lost, in some places, over a third of its population. The life of the working woman in peasant society can only be imagined.

In such an environment, the care of their babies and young children, as well as themselves, must have presented considerable challenges.

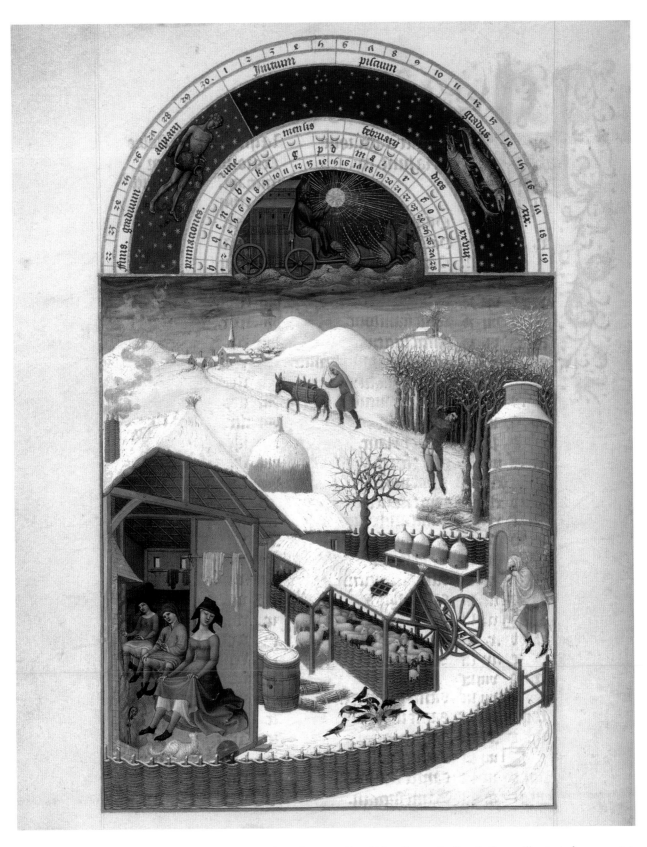

February (c 1416). Miniature by The Limburg Brothers from *Les Très Riches Heures du Duc de Berry*. Illuminated manuscript, 15.4 cm × 13.6 cm. *Chantilly, musée Condé*.

8

The Wedding Feast (c 1568)
by Pieter Bruegel the Elder

Pieter Bruegel was born around 1525, possibly in a village in north Brabant, married in 1563 and died in Brussels in 1569. In his relatively short life, he became the founder of the Flemish group of painters, was a master draughtsman and was universally popular. Having started his art studies in Antwerp, in his twenties he travelled to Italy, where he made a series of sensitive landscape drawings.

His works range widely, but he is best known for his many genre paintings, of scenes from everyday life, a field subsequently made famous by a number of other Flemish and Dutch artists, including Adriaen Brouwer, Gerrit Dou and Jan Steen. He was survived by his two sons, Jan and Pieter the Younger, who also became renowned artists.

The scene in this work is clearly a very happy one, everyone sharing in the joyous event. But, as in many genre works of the period, there is much detail, some with particular meanings at the time.

The furniture is simple wooden tables and benches. The only chair with a backrest has been reserved for an old man, perhaps the bride's father or possibly the notary who drew up the marriage contract. The event is taking place in a large barn. The two sheaves of corn held together by a rake whose handle is buried in stacked cereal imply that there has been a good harvest. At the time, the threat of a bad harvest and starvation were never far from the mind. The spoon in the waiter's hat was a sign of poverty. Peasants with no land were forced to be itinerant farm labourers, and often depended on charity for a bowl of gruel – hence the spoon. It is not clear whereabouts the bridegroom is. He may be the man filling the jugs of beer. However, according to some authorities on the work, wedding feasts are known to have taken place without the bridegroom being invited, for a wedding day was essentially the day of the bride. She is easily identified below the bridal 'crown'. She is displaying her long hair in public for the last time; subsequently, it would be hidden beneath a bonnet. Incidentally, the facial appearance of the bride has been interpreted by some that she may have had myxoedema. To us, it seems much more likely that she is merely relaxed, contented and enjoying the event – perhaps the only day in her entire life when she was not expected to work.

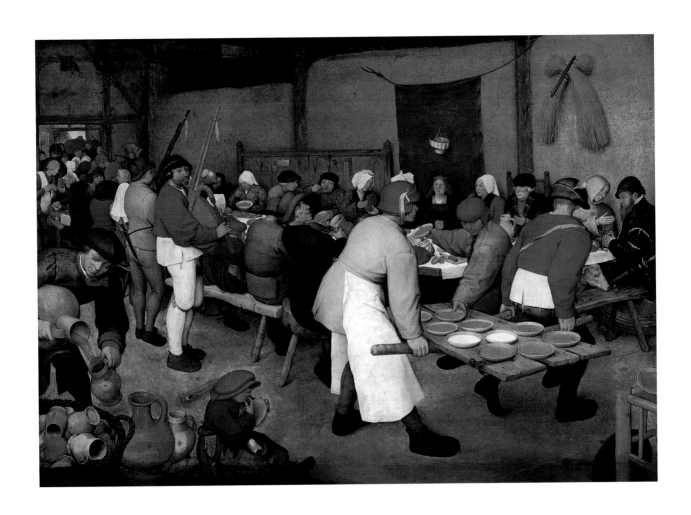

The Wedding Feast (c 1568) by Pieter Bruegel the Elder. Oil on panel, 114.3 cm × 162.6 cm. *Vienna, Kunsthistorisches Museum.*

9

The Health of the Bride (1889)
by Stanhope Forbes

Wedding scenes have attracted painters from the 15th century onwards, with Jan van Eyck's *The Arnolfini Marriage* of 1434 possibly the most famous. Incidentally, Jan and his brother Hubert are traditionally credited with having introduced oil painting. The preceding Bruegel work of the 16th century is in stark contrast to this Victorian painting of the same subject by Stanhope Forbes. It is still essentially a rural scene, but in the intervening three centuries, as expected, much has changed.

Stanhope Forbes (1857–1947), who settled in the Cornish village of Newlyn in 1884, became the foremost figure in the 'Newlyn School'. He and his colleagues were leading pioneers of *plein air* (open air) painting in Britain favoured by the milder climate of the South West of England. He created many attractive paintings of the Cornish scene, most notably *A Fish Sale on a Cornish Beach*, exhibited at the Royal Academy in 1885 – a scene very far removed from metropolitan life in London. Many of the paintings by Forbes and his friends depicted village scenes, sometimes portraying the tragic life of fisherfolk at the time.

Here we see a happy event in a somewhat grander house than those inhabited by fishermen and their families; there is even a maid shown on the left. But the sailor raising a toast to the bridal couple reminds the viewer of the closeness of the sea. The bride still holds her bouquet and appears appropriately demure. It is a family scene with grandfather engagingly involved with his grandchildren. Although somewhat sentimentalized, to Victorian audiences and resonating today, it portrayed the importance of a stable partnership.

Nowadays, however, there is a wide range of marriage patterns. Although often based on romantic attachment, in some countries marriages are arranged by parents, with the bride joining the extended family of the groom and thereafter living in daily contact with her inlaws. The marriage of social equals is emphasized in many romantic novels of the past. In 17th century England, for example, one-third of clergymen's children married other clergy.

In present-day Western Europe, couples frequently live together as partners without any official sanction. In Britain, for example, over 40% of all children are born outside marriage, which is a reflection of the rising trend in cohabiting parents. Furthermore, in recent years in Britain, the birth rate has been gradually declining and roughly one-third of marriages end in divorce. The social consequences of all these changes can easily be imagined.

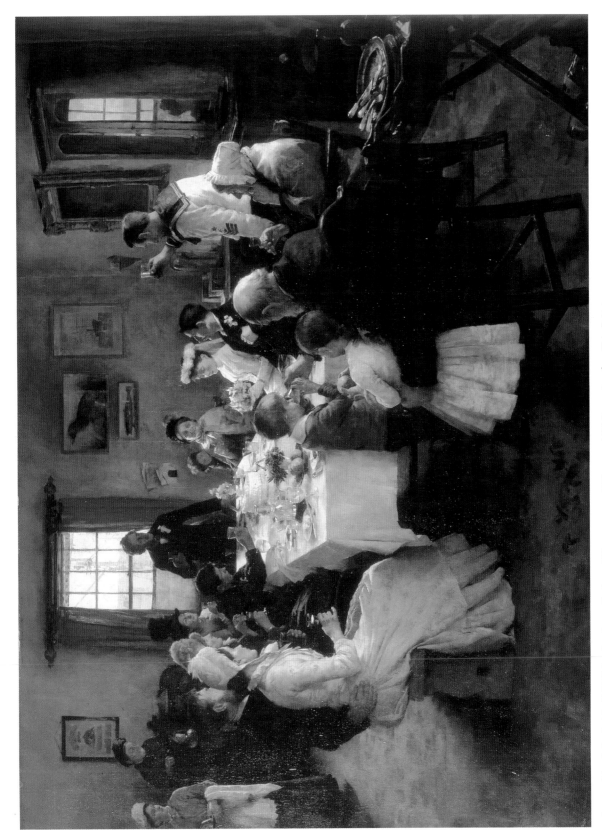

The *Health of the Bride* (1889) by Stanhope Forbes. Oil on canvas, 152 cm × 199.8 cm. *London, Tate Britain.*
©Tate, London 2006.

10

Pregnant Woman (Maternity) (1913)

by Marc Chagall

Marc Chagall (1887–1985) was born into an impoverished Jewish family in Vitebsk, Russia. He first studied in St Petersburg, then went to Paris in 1910, where he found the art world particularly stimulating. Four years later, he went back to Russia, only to return to France again in 1923, where, apart from a brief period spent in the USA during the German occupation, he remained.

His Jewish and Russian background continued to influence much of his work throughout his long and productive life. His name in Russian is synonymous with the verb 'to stride', implying his prodigious energy in his lifelong devotion to art.

His work often gives a fantasy-like, fairy-tale impression, but he himself was quick to emphasize its deeper meaning, and his paintings are very often directly reminiscent of his early years in Russia.

This painting of a pregnant woman is replete with meaning. She is wearing a Russian peasant dress and points to the fully developed male child in her womb. Her face, green and intense, incorporates the profile of a bearded man, perhaps her husband or father. The various rural images – a cow, a peasant working with a horse, and the farm buildings – clearly set the scene. The moon and vivid colours heighten the dramatic effect. The rhythms and cycles of Russian country life are reflected in the title of another very similar work: *Mother Russia*. Whatever the interpretation, the artist was not so much concerned with the biological details of pregnancy, but rather with more fundamental aspects of his own personal experiences.

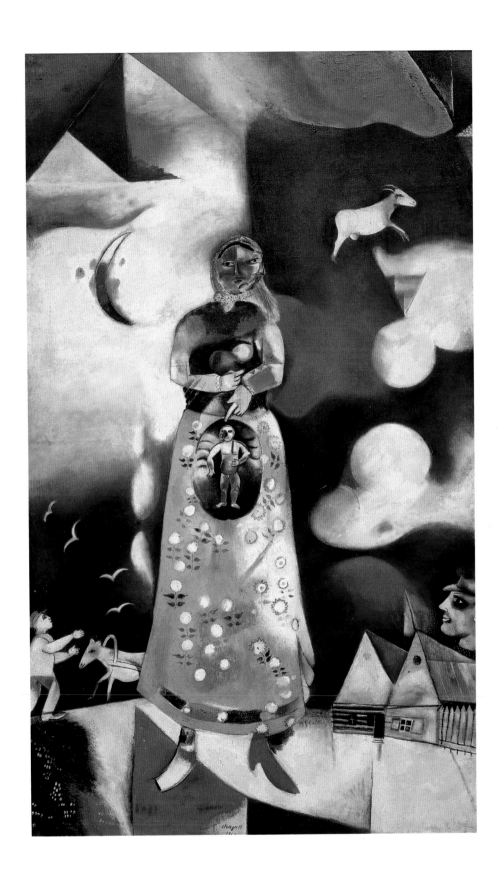

Pregnant Woman (Maternity) (1913), by Marc Chagall. Oil on canvas, 194 cm × 114.9 cm. *Amsterdam, Stedelijk Muserum.*

11

The Longing of a Pregnant Woman (1839)

by Honoré Daumier

In one important respect, William Hogarth in England and Honoré Daumier (1808–1879) in France shared a common interest – they both satirized events and people of their age. Daumier in particular often ridiculed unscrupulous lawyers and bankers, as well as doctors who were avaricious and boastful and especially those who were clearly charlatans at the time. Although often vilified by some, he was also admired by several famous artists of the period, including Delacroix, Millet and Corot. He never made very much money from his work and remained poor throughout his life. In old age, he underwent a cataract operation, which was unsuccessful. This caused Monet considerable concern when years later he faced the same problem, although in his case surgery was successful.

In this lithograph entitled *Une Envie de Femme Grosse* or *The Longing of a Pregnant Woman*, Daumier has depicted a pregnant woman biting the arm of a butcher who appears to be delivering hams. This craving for particular foods often occurs in pregnancy, as well as in some deficiency diseases. According to one survey, more than half of all pregnant women had an urgent craving for certain foods, such as confectionary and fruit. A small proportion of pregnant women have a longing to eat substances that are not foodstuffs including coal and clay. This can also occur in children as well as adults who have iron-deficiency anaemia. The term *pica* has been used in this regard – a word which in the *Oxford English Dictionary* has had many different meanings, including a bird, a particular type size in printing, and, from the 16th century, an unnatural appetite during pregnancy. It is interesting to speculate that this craving in pregnancy may reflect the body's need for certain vitamins and elements, but it is hard to imagine the molecular details of such a process.

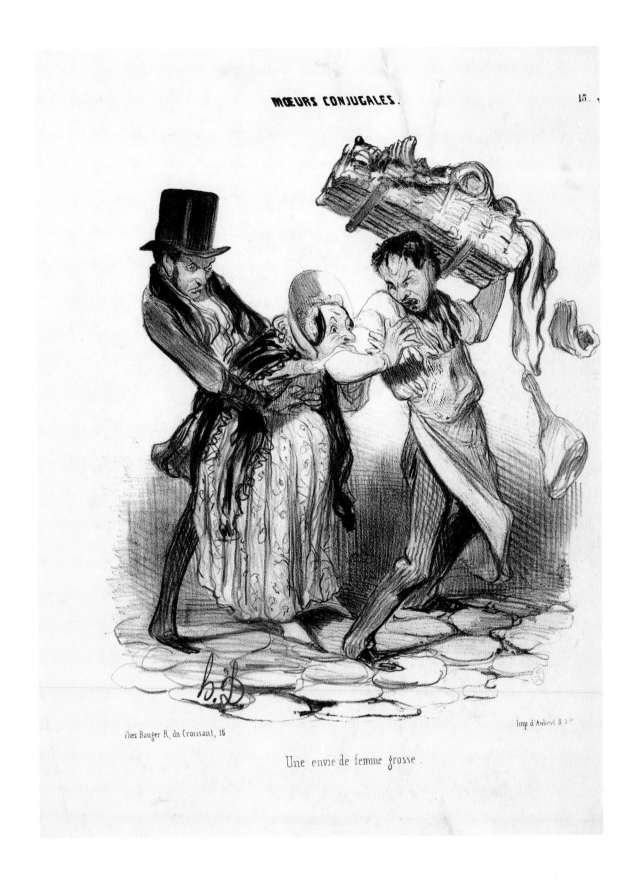

The Longing of a Pregnant Woman (1839) by Honoré Daumier. Lithograph, 234 cm × 199 cm. *London, British Museum.*
© Copyright of the Trustees of The British Museum.

12

Cunicularii, *or* The Wise Men of Godliman in Consultation (1726)

by William Hogarth

Abnormal birthmarks, such as a strawberry haemangioma, and congenital deformities were attributed in Ancient Greece to the displeasure of the gods, for whatever misdemeanour. Later, witchcraft was often blamed. Up until the end of the 18th century, a common belief was that maternal impressions before conception or during pregnancy could be the cause. The effects of the mother's imagination on the state of the fetus was accepted by both laypersons and many professionals, and satirized in several novels of the period, including Sterne's *Tristram Shandy*, Fielding's *Joseph Andrews* and Smollett's *The Adventures of Peregrine Pickle*.

In this work, William Hogarth (1697–1764), the great English satirist who was both a renowned painter and engraver, illustrates the case of Mary Toft. Her story has been told in fascinating detail in Fiona Haslam's *From Hogarth to Rowlandson* (Liverpool University Press, 1996). Mary came from Godalming (Godliman) in Surrey, and in 1726 convinced many of the medical profession of the time that in early pregnancy she had been surprised by rabbits while she was weeding, and subsequently gave birth to rabbit parts and whole rabbits. Several doctors and man-midwives attested to this at the time. But eventually, after a thorough investigation, Mary confessed to fraud. It appeared that, following an early miscarriage, an accomplice had inserted rabbit material into her vagina. The purpose had been to obtain a good livelihood, which the accomplice hoped to share in return for the supply of rabbits. But the idea would never have been entertained if the belief that maternal impressions could influence the unborn baby had not been widely held. It took some time for a number of medical reputations to heal and for the idea to be dismissed as absurd. Yet even today genetic counsellors often have to assure parents that whatever they may have experienced or done in the past has no bearing on the cause of their child's congenital abnormality or genetic disorder.

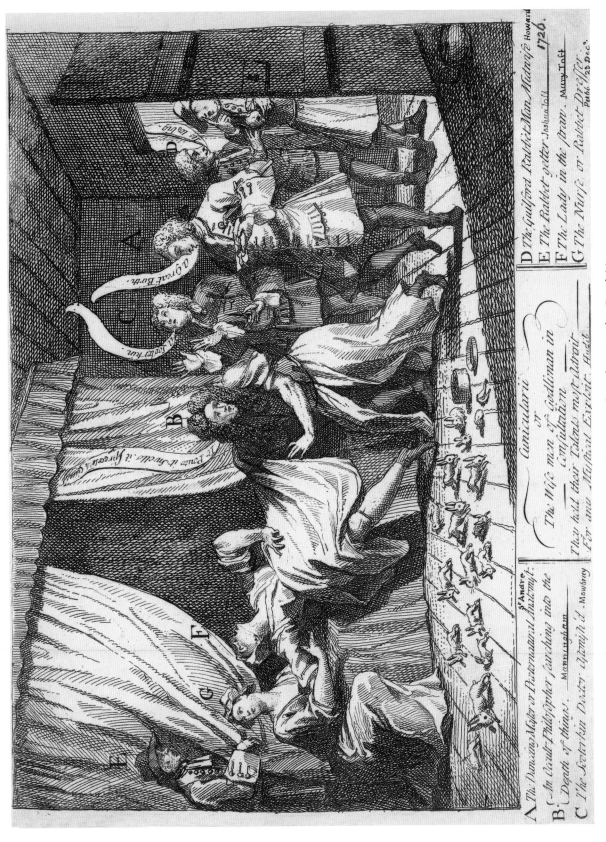

A The Dæmon Master or Præternatural Anatomist. — St Andre.
B { An cloud-Philosopher searching into the } — Manningham.
 { Depth of things. }
C The Sooterkin Doctor disméyd. L. Mowbray

D The Guilford Rabbit-Man Midwife. — Howard
E The Rabbit getter. — Joshua Toft. 1726.
F The Lady in the Straw. — Mary Toft
G The Nurse, or Rabbit Dresser.
 Publ. 25 Decr

Cuniculari̅i̅
or
The Wise men of Godliman in
Consultation.
They held their Talents most Adroit
For any Mystical Exploit. Aud:

Cunicularii, or *The Wise Men of Godliman in Consultation* (1726) by William Hogarth. Etching. *London, British Museum.*

© Copyright of the Trustees of The British Museum.

13

Birthing Stool, Ancient Egypt (Roman period, c AD 150–200)

Drawing of temple relief, Kom Ombo

The Queen Delivering in Ancient Seated Posture (1236–1237)

Manuscript illustration by al-Wâsitî from The Maqâmât of Al-Harîrî

Possibly the earliest representation of childbirth is of a seated female figure of around 6000 BC from Catal Huyuk in central Turkey. Other images from early times show women giving birth in a squatting position or kneeling. On some occasions, the pregnant mother sat on a helper's lap, but very often a birthing stool or chair was used. This appears to have been so in Ancient Egypt, as illustrated in a relief on the wall of the temple of Kom Ombo around AD 150–200. The midwife would sit opposite the woman, allaying any fears and directing the mother to push down, with an assistant exerting mild fundal pressure. Such deliveries were almost always the province of a midwife and usually in the mother's home or, in some communities, in a special hut or place reserved for the purpose. It was only in the 18th century that male obstetricians more often attended deliveries and special lying-in hospitals were founded.

For what, not infrequently, could be a very painful experience, the only relief at all effective was a variety of herbal preparations of mandrake, poppy and henbane. However, chloroform was shown for the first time in 1847 by James Young Simpson (1811–1870), Professor of Midwifery in Edinburgh, to be the most effective and preferred agent for inhalation anaesthesia. And it became widely accepted in 1853 when Queen Victoria allowed chloroform anaesthesia to be used for the birth of her son Leopold. Subsequently, other agents were introduced for general anaesthesia. Pethidine and its derivatives as well as various tranquilizers were used later. From the 1970s, lumbar epidural analgesia became the preferred option for most deliveries for effective pain control.

Research has recently indicated that birthing pools, introduced back in the 1970s, where the mother immerses herself in water at body temperature during labour, facilitate birth and can reduce the need for an epidural. Newborn babies, in fact, have powerful diving reflexes and are well adapted to immersion at birth.

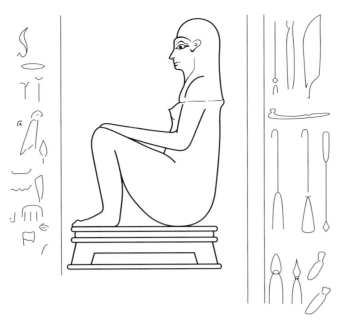

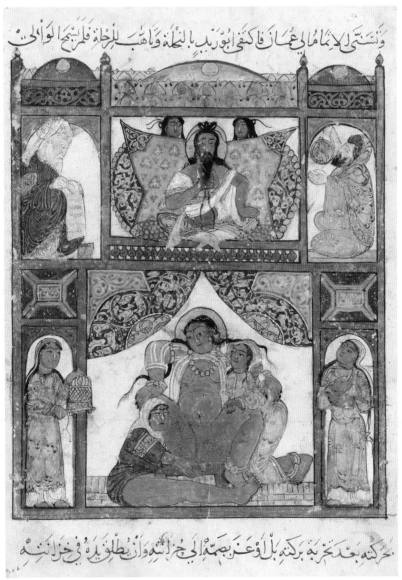

Upper figure: **Birthing Stool, Ancient Egypt** (Roman period, c AD 150–200). Drawing by authors from carved temple relief, Kom Ombo.

Lower figure: **The Queen Delivering in Ancient Seated Posture** (1236–1237) by al-Wâsitî from *The Maqâmât of Al-Harîrî*. Manuscript illustration. *Paris, Bibliothèque nationale de France. (MS arabe 5847, fol. 122v).*

14

Caesarean Section (c 1000)

from an illuminated manuscript, Al-Asrar-al-Baqiyah-an-al-Quran-al-Khaliydh (Chronological History of Nations) *by al-Beruni*

Caesarean section refers to the procedure whereby the baby is removed from the pregnant uterus by incising the anterior abdominal wall of the mother. The origin of the term is puzzling. A common belief is that the Roman emperor Julius Caesar was born this way in 100 BC. Some have even depicted this event in their art. But his mother Aurelia lived for many years after his birth, which would have been quite impossible at the time. It seems more likely that, as suggested by Haubrich, the term is derived from the Latin *Lex Caesarea* referring to Roman law that dealt with such matters.

The idea of delivering a baby through the abdominal wall does, however, occur even in Greek mythology. For example, Apollo fell in love with Coronis, but when he discovered she was with child and had been unfaithful, he removed the unborn child, Asklepios (Latin: Aesculapius), from her womb. Asklepios was then brought up by the wise centaur Chiron, from whom he learnt the art of medicine and in turn became the Greek god of medicine.

Until effective analgesia and the control of infection and bleeding were introduced in the 19th century, the operation (if performed at all) was to save the life of the infant when the mother had died. However, by the late 19th century, Caesarean section was being recommended specifically for certain intrauterine fetal positions that prevented a normal vaginal delivery, placenta praevia and pelvic deformations. A variety of surgical methods were developed, but mortality remained high – often because the procedure was considered only after a prolonged and difficult labour. But as techniques improved and morbidity and mortality rates fell, other indications for Caesarean section became accepted, including fetal distress and prolapse of the cord, and it was often considered when a mother had had a previous Caesarean section.

At the beginning of the 20th century, the procedure was carried out in less than 2% of labours, but now the rate often exceeds 10% in some centres. Women and their obstetricians may opt for surgical intervention, particularly in the more affluent sections of society, because it may be seen as more convenient than perhaps a difficult and prolonged labour.

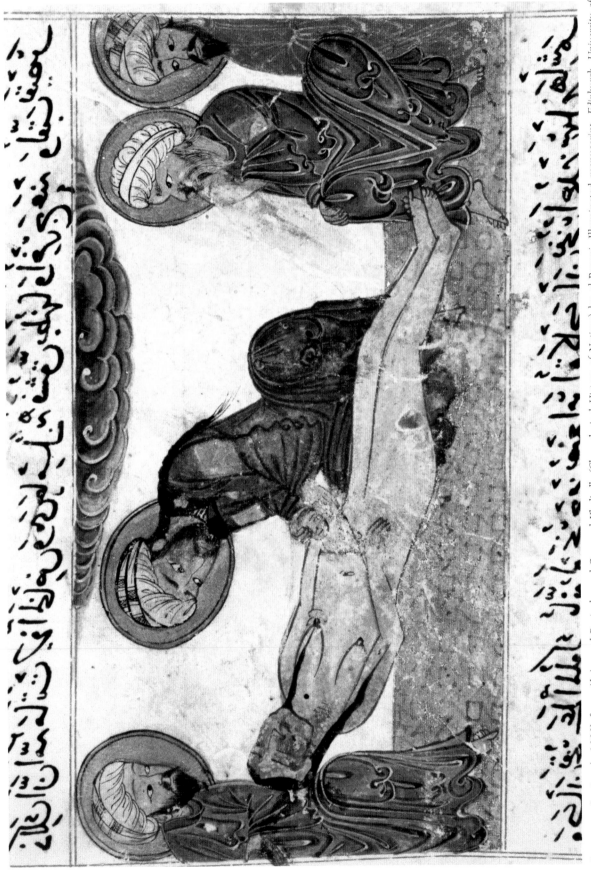

Caesarean Section (c 1000) from *Al-Asrar-al-Baqiyah-an-al-Quran-al-Khaliydh* (*Chronological History of Nations*) by al-Beruni. *Illuminated manuscript. Edinburgh, University of Edinburgh Library. (ORMS 161, f. 16v).*

15

Oliver Wendell Holmes Reading *The Contagiousness of Puerperal Fever* Before The Boston Society for Medical Improvement in 1843 (1946)

by Dean Cornwell

Puerperal fever or sepsis or, as it was once termed, childbed fever was a major cause of maternal mortality, and ravaged lying-in or maternity hospitals until its cause was determined. Mary Wollstonecraft, the 18th century radical and brilliant author, died from the disease a few days after giving birth to her daughter, who was later to marry Shelley and write the novel *Frankenstein*.

It was rightly named, for it presents a few days after delivery with high fever, rigors, painful and tender uterus, and foul lochia. It had been recognized from earliest times and was described by Hippocrates in his *Epidemics*. Three important names are now associated with discovering its cause. Alexander Gordon (1752–1799) of Aberdeen in his treatise on the subject published in 1795 realized that it only occurred after delivery and was transmitted by infected material from one case to another. For implying that it was transmitted in this way, he was vilified by colleagues and midwives and forced to leave Aberdeen, developed tuberculosis and died at the age of 47 a very disappointed man.

Subsequently, Gordon's findings were rediscovered by Oliver Wendell Holmes (1809–1894), the American physician and writer. While Professor of Anatomy and Physiology at Dartmouth College in 1843, he found that puerperal fever was contagious. In this painting by the American illustrator Dean Cornwell (1892–1960), the scene is imagined of Holmes reading his essay on the subject to his colleagues, presumably of the then Boston Society for Medical Improvement. The painting was part of a series *Pioneers of American Medicine* commissioned by the Wyeth Laboratories in 1939–1942.

However, it was the Hungarian Ignaz Semmelweis (1818–1865) who made the most notable contribution to the subject while working in the obstetric clinic of the Vienna general hospital. In the late 1840s, by initiating a strict regime, with medical attendants and students washing hands and instruments in chlorinated lime solution between autopsies and examining patients, the mortality rate fell significantly. But again there was much opposition to his views, and, frustrated and depressed, he left Vienna in 1850, later dying in a mental asylum. The rejection of his views by his colleagues may in part have been a reflection of his paranoid personality and in part his Hungarian background, an uprising by his fellow-countrymen only just having been suppressed.

With the subsequent work of Pasteur and Lister and the development of the germ theory of disease and antiseptic procedures, and later with effective treatment using antibiotics, mortality from the disease fell significantly. In Britain, a maternal death from this disease is now a very rare event, in stark contrast to the early 19th century, when it was a major cause of maternal morbidity and mortality in lying-in hospitals.

Oliver Wendell Holmes Reading The Contagiousness of Puerperal Fever Before the Boston Society for Medical Improvement in 1843 or *That Mothers Might Live* (1946) by Dean Cornwell. Oil on canvas, 147.3 cm × 166.4 cm. *Philadelphia, Wyeth Laboratories.* Published with permission of Wyeth.

16

Her Firstborn (1877)

by Frank Holl

This poignant work by the Victorian artist Frank Holl (1845–1888) reflects the anguish and depression experienced by a family at the death of an infant. Frank Holl trained at the Royal Academy Schools in London and was awarded a travelling scholarship that allowed him to visit Europe for further training and experience. He was particularly impressed by Holland and the work of Jozef Israels, who often painted poverty-stricken peasantry. This experience affected the choice of subjects for many of Holl's subsequent works. Here the mien of the characters emphasizes only too clearly the pathos of the situation. The painting is set in Shere churchyard in Surrey. It shows a procession of mourners led by four young girls carrying the tiny coffin in a white cloth pall. The father and grandfather in smocks follow, with the weeping mother in the centre, almost fainting in her grief. Holl is said to have worked himself to death, dying at the early age of 43.

At the time of the painting the infant mortality rate was around 150 per 1000 live births, compared with the present rate of around 5. Problems associated with the birth as well as infections were frequent causes. A few years ago, we noted that this was still the case in one large hospital in South India. In Britain nowadays, proportionately more cases are attributed to congenital defects and genetic conditions. There has also been a recognition of 'new' conditions that, although rare, attract much research, such as sudden infant death syndrome. It has been said that whereas a thousand deaths is a statistic, a single death is a tragedy. Holl has caught the tragic personal loss of a childhood death with great feeling.

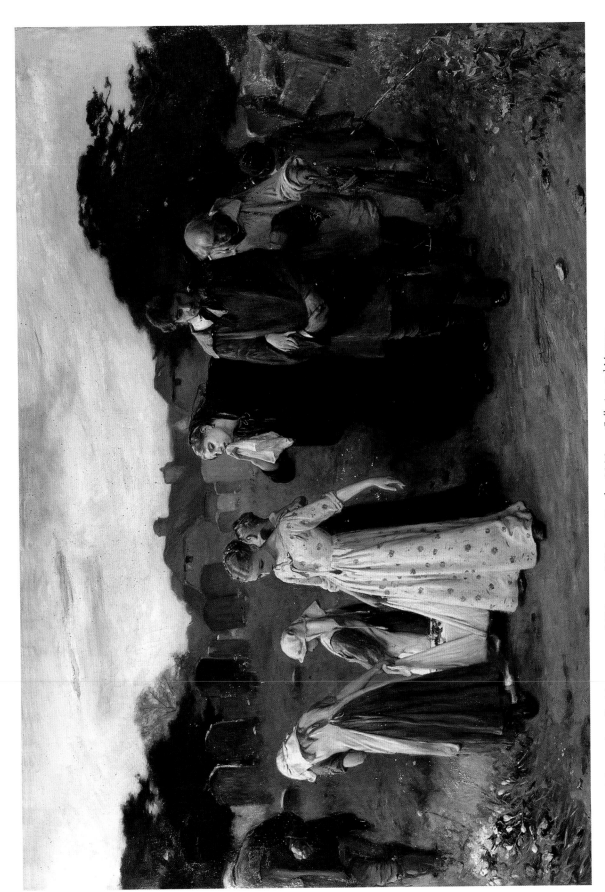

Her Firstborn (1877) by Frank Holl. Oil on canvas, 109.2 cm × 155.6 cm. *Dundee, McManus Galleries and Museum.*

17

Mother and Child (1979)

by John Muafangejo

The importance of breastfeeding has always been recognized, and the World Health Organization recommends that it should continue for at least two years. Soranus of Ephesus (AD 98–138) also recommended that it should be continued for up to two years, as does the Koran: 'The mothers shall give suck to their offspring for two whole years...' (Sura II, 233). It was probably recognized in the past that infants fed on cow's or goat's milk were more likely to die – as we now know from enteritis. It was probably also realized that the amenorrhoea associated with breastfeeding resulted in contraception. However, this is ineffective in a small proportion of women and the contraceptive effect decreases after six months. Of course, breastfeeding also reinforces bonding between mother and child, although it is now contraindicated where HIV infection could be transmitted to the baby.

Breastfeeding can be very painful if the nipple becomes cracked and inflamed. Despite having this problem, Sonya Tolstoy was forced by her husband to continue breastfeeding, since he thought that wet-nursing was disgusting and unnatural. Nevertheless, they had 13 children. Up until the 19th century, upper class women often employed a wet-nurse for breastfeeding. Sometimes, the latter would resort to using an artificial nipple to protect against any risk of catching syphilis from the child. Wet-nursing went out of fashion with the introduction of the nursing bottle in the 19th century.

Over the centuries, artists have frequently depicted mothers breastfeeding their infants. This particular illustration was selected because of its immediate impact on the viewer. One has to agree with Nelson Mandela that John Muafangejo's work is quite dazzling. It is also a reflection of the traditions and life of the people of South Africa. Muafangejo was born in 1943 in Angola, but his father died when he was young and his mother moved to South Africa, where he later obtained art training at Rorke's Drift, Natal. Thereafter, he went on to exhibit his work not only in South Africa but also in Washington, Helsinki and Germany, as well as the UK, and has been awarded a number of prizes. This particular illustration is a linocut, but he has also produced etchings and woodcuts. He has clearly captured the close relationship between mother and child mutually embracing each other during breastfeeding, more effectively than some more sophisticated works of art have done.

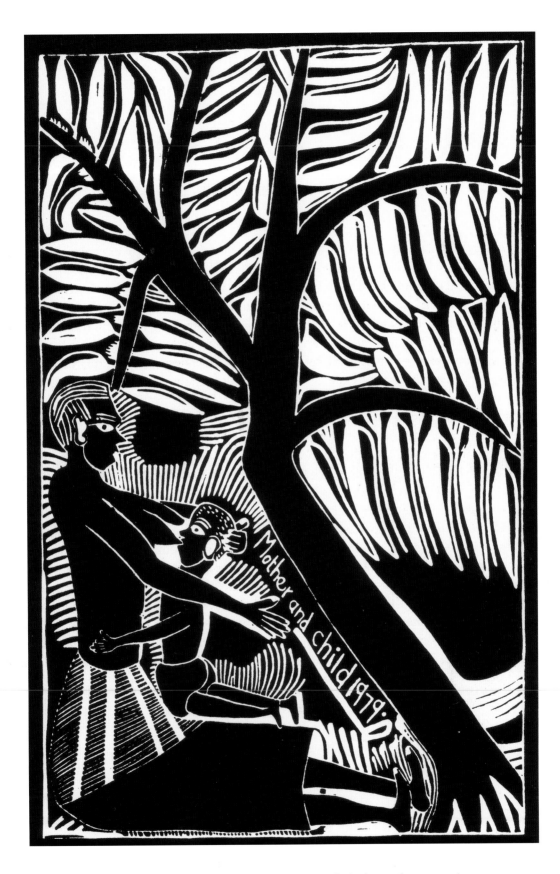

Mother and Child (1979) by John Muafangejo. Linocut, 46 cm × 30 cm. *Oxford, John Muafangejo Foundation.*
Reproduced by kind permission of Mr Orde Levinson.

18

The Circumcision of Christ (1471–1481)
altarpiece by Michael Pacher

In the very first detailed account of the lives of Aboriginal tribes of Australia, Spencer and Gillen noted that many underwent circumcision in boyhood (*The Native Tribes of Central Australia*, Macmillan, 1899). It was part of an elaborate religious ritual. In some instances, the urethra was also incised at the base of the penis, producing an artificial hypospadias, but this was more for the purpose of contraception. Circumcision was also carried out on young boys in Ancient Egypt, as shown in a famous relief in the tomb of Ankh-ma-hor, Saqqara cemetery at Memphis, of around 2345 BC.

The practice of circumcising male infants continues today in Jewish and Muslim communities. This beautiful illustration shows the ritual practice being deftly carried out on Christ. The artist, Michael Pacher (c 1435–1498) was an Austrian painter and wood carver. He worked mainly for local churches, carrying out the carving and painting of altarpieces, and much of his work is still *in situ*. The astonishing detail of his work is evident in this illustration.

Female 'circumcision', which seems to have arisen as a means of dominating women in certain societies, is now rightly condemned and illegal in the West. Male circumcision, on the other hand, although usually a religious practice, may have arisen partly for hygienic reasons. In hot arid conditions, where water was scarce, it could prevent material accumulating under the prepuce and resulting in balanitis. This would account for the tradition being practised in desert areas of the world, but being virtually unknown in communities living in tropical rain forests. Nowadays, it has been questioned whether circumcision is justified on grounds of hygiene. One eminent textbook of paediatrics concludes that there are virtually no medical or surgical reasons for performing this operation on the newborn infant. Yet recent research has revealed that the rate of HIV infection, and possibly some other sexually transmitted diseases as well, may be higher in uncircumcised males. The debate will no doubt continue.

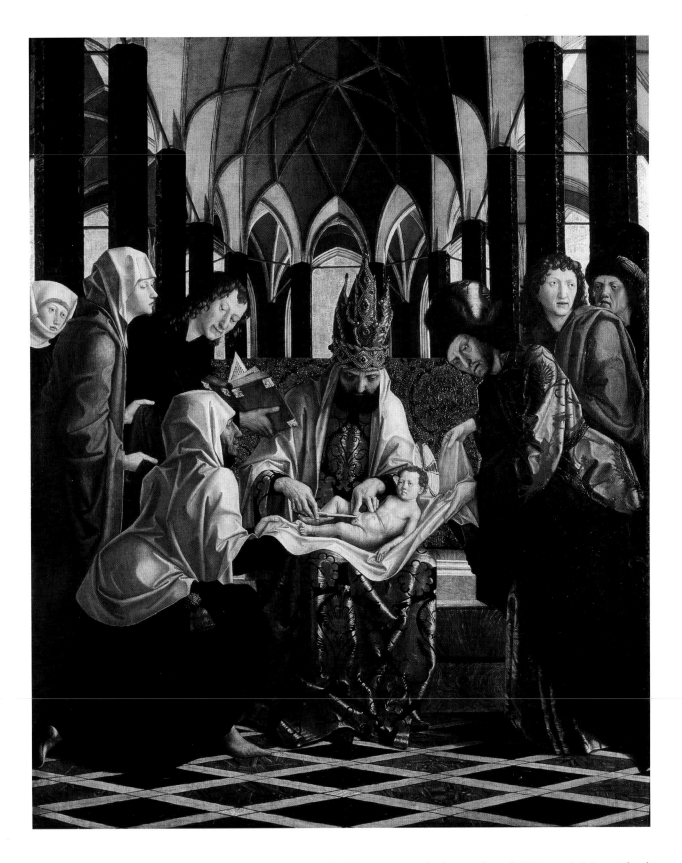

The Circumcision of Christ (1471–1481) altarpiece by Michael Pacher. Painting on linden wood panel, 173 cm × 140.5 cm. *Church of St Wolfgang, St Wolfgang am Abersee, Austria.*
Reproduced by kind permission of St Wolfganger Kunstverlag.

19

The Adoration of the Shepherds (c 1644)

by Georges de la Tour

Congenital dislocation of the hip is one of the commoner problems that can occur in early childhood. Family studies have shown that both genetic and environmental factors are responsible – this is a so-called multifactorial condition. This means that although there is a slightly increased risk to other close relatives, the genetic predisposition is manifested by environmental factors. One factor is swaddling in infancy. Binding prevents the legs from moving freely, which then interferes with the proper development of the hip joint. Among the Navajo Indians, where swaddling was universal at one time, the incidence of the condition was one of the highest recorded. Furthermore, tight swaddling could restrict the child's breathing. In fact, the English clergyman, Dr Stephen Hales, an early pioneer in the study of blood pressure and the circulation, in 1743 roundly condemned the practice for this reason.

There have been numerous works of art depicting swaddling, many with a religious theme. In this painting, for example, the shepherds are seen adoring the baby Jesus, who is tightly trussed up in tight swaddling clothes. The artist, Georges de la Tour, was born in Vic-sur-Seille in 1593. He married and fathered 10 children, only one of whom reached adulthood. He became a well-known artist in his day, and many of his works have a religious theme as in this case. He died in 1652, and is nowadays revered for his dramatic use of lighting, so-called *chiaroscuro* (Italian: bright-dark), which had been pioneered by Leonardo de Vinci, followed by Caravaggio. La Tour very often used candlelight to heighten effects in his paintings. Here it clearly focuses the viewer's attention on the infant Jesus.

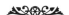

The Adoration of the Shepherds (c 1644) by Georges de la Tour. Oil on canvas, 107 cm × 131 cm. *Paris, musée du Louvre (RF 2555 G/AR).*
© Photo RMN/© Gérard Blot.

20

Child Being Given a Fomentation (Poultice) (early 13th century)

*anonymous, Italian medical manuscript in Latin,
copy of original 6th century manuscript*

Nursing care in the West had its origins in Christianity and was often the responsibility of nuns, especially with the care of children. St Felicity of Carthage became the patron saint of sick children, and nursing care by various religious orders continues in some centres even today. But in the early days there was little in the way of treatment that they could offer, apart from various herbal remedies and simple procedures, such as the application of a poultice for abdominal pain, as in this 13th century manuscript.

As society evolved, nursing care gradually became secularized. But such care could sometimes be far from the ideal. This was epitomized in Dickens' Sarah Gamp, a character from *Martin Chuzzlewit*, a slatternly, often drunk old nurse and midwife. Around the time this novel was published, matters began to change with the establishment of the Institute of Nursing by Elizabeth Fry in London in 1840 and the exemplary work of Florence Nightingale following the Crimean War. Nurse training schemes began to evolve not only in Britain but also other countries, for example by the redoubtable Dorothea Dix in America. In these early days, nursing was seen as almost an extension of household work, and was to attract widows and spinsters mainly from the middle classes who might find other employment difficult. The work was hard and long, involving cleaning and washing patients, changing bed linen, and even cleaning wards.

The need for a professional body to regulate standards of training and for registration resulted in the establishment of the General Nursing Council in 1919, and State Registered Nurses had their own Royal College of Nursing. Gradually, the profession became increasingly specialized with the development of paediatric nursing, which could often be very demanding, as in the case of intensive care nursing and premature infant care. And there are now moves to have nurses more directly involved in treatment.

But, however specialized and skilled, the nurse is perhaps the one health professional who can provide the attention, care and comfort which patients so often need – very like her mediaeval predecessor.

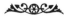

Child being beaten pulcium trum cum aqua aū acecoin· ad nausum stomachi·
potin dab nausiam stomachi sedat·

Child Being Given a Fomentation (Poultice) (early 13th century). Italian medical manuscript in Latin, copy of original 6th century manuscript. *Vienna, Austrian National Library.*

21

A Man-Mid-Wife (1793)

hand-coloured etching by Isaac Cruikshank from John Blunt's Man-Midwifery Dissected

Midwives have been respected members of society from ancient times. They were often parous post-menopausal women and could enjoy high social status, particularly those involved in the birth of royalty. But for the most part they were typically illiterate and learnt their craft by example from other midwives. Before the 18th century, almost all babies were delivered by female midwives, although in difficult cases a doctor might be called in to assist. But as the secret of the Chamberlen forceps was revealed in the 18th century, midwives started to be used more widely, and man-midwifery became part of the practice. However, the entry of men into what had previously been the province of women was much criticized by some. Many women objected to the presence of men during labour, as did their husbands. This coloured etching of 1793 illustrates the controversy. It is taken from a book, *Man-Midwifery Dissected*. The author, John Blunt, a pseudonym for the publisher Samuel W Fores, argued that male midwives were unnecessary and their practice 'indecent and cruel'. Isaac Cruikshank, a contemporary caricaturist not to be confused with his later more distinguished sons, was commissioned to do the frontispiece. On the right is the homely midwife who offers a feeding cup and is featured in a domestic setting. In contrast, the man-midwife holds forceps ('lever') and on the shelves are more horrific instruments as well as love potions ('for my own use'). The contrast and conclusions are clear. Even today, there are seeds of the controversy: most babies are delivered by male obstetricians in America but by female midwives in the UK. On the other hand, increasing numbers of women nowadays are becoming obstetricians whose work is almost entirely limited to hospital practice.

In Britain, midwives have retained their important role in the speciality. State certification was introduced in 1902 and their status further enhanced by the 1936 Midwives Act; other regulatory acts and statutory bodies have followed, including the establishment of the Royal College of Midwives in 1947.

Many of us who qualified some years ago and had the great experience of delivering babies 'on district' remember with gratitude the advice and help of a friendly experienced midwife. They were often familiar with the mother as well as other female members of the family and local neighbours. They invariably brought much comfort and support to the mother and her family.

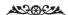

A Man-Mid-Wife (1793) by Isaac Cruikshank. Hand-coloured etching, 25.2 cm × 20.3 cm.

From: Man-Midwifery Dissected *by John Blunt, London: Samuel Fores, 1793. London, Royal Society of Medicine Library.*

22

Newborn Baby on Hands (Ursus Dix) (1927)
by Otto Dix

As the renowned medical historian Irvine Loudon has pointed out, before the early 18th century, childbirth was a social rather than a medical occasion and was managed almost exclusively by midwives. But by the end of the 18th century, attitudes were changing and general practitioners became increasingly involved in ordinary confinements in the home. To many, it became an important part of their practice, for it offered the possibility of following family members from birth and possibly for the rest of their lives. But the work was often extremely demanding for an already busy practitioner. There was also always the very real concern of the possible death of the mother.

Because of a lack of professional training, practitioners frequently disregarded antisepsis and sometimes were frankly incompetent. In the first part of the 19th century, they were often reluctant to intervene in a normal pregnancy, yet later in the century intervention became fashionable and even excessive. There was a real need for professional training.

The first maternity hospital in London was Queen Charlotte's Hospital (founded in 1739), and a few years previously Edinburgh had established the first Chair of Midwifery. But it was not for another century that medical students were required to study obstetrics, first in Scotland in 1833, and later in England. Obstetrics, however, remained a branch of surgery right up until 1929, when the Royal College of Obstetrics and Gynaecology was founded. Thenceforth, there was, as in all other branches of medicine and surgery, legal and professional control of all those who practiced obstetrics.

The subject of this work is unique for the artist, Otto Dix (1891–1969). He has painted in realistic detail his newborn son Ursus. The arrangement of the limbs, including the upturning big toes, has been achieved with great feeling. This is in very stark contrast to much of the artist's other work, which, like many German artists of the period, centred on the decadence they saw in their post-First World War country. The background in Dix's work was always important in defining the subject. Perhaps no better way to illustrate this in the case of his newborn son was to show him being lovingly cradled in the warmth and protection of an attendant's hands.

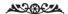

Newborn Baby on Hands (Ursus Dix) (1927) *[Neugeborenes auf Händen (Ursus Dix), 1927]* by Otto Dix. Mixed media on plywood, 50 cm × 43.5 cm. *Stuttgart, Kunstmuseum.*
© DACS 2006.

23

Esau and Jacob Presented to Isaac (c 1780)

by Benjamin West

There are essentially two types of twins recognized in humans: non-identical or dizygous twins derived from the fertilization of two separate ova at around the same time, and identical or monozygous twins derived from the splitting of a single fertilized ovum at an early stage of development.

Whether consciously or not, the very rare possibility of non-identical twins having different fathers (now referred to as *super-fecundation*) is implicit in the Greek heroic legend whereby Heracles and his twin Iphicles were believed to be due to their mother having had relationships around the same time with Zeus as well as with her husband Amphitryon.

Twins as such have attracted writers perhaps more than artists. It was recognized that male twins could rival each other, as in the case of Heracles and Iphicles, and Esau and Jacob. The latter are shown in this painting by Benjamin West (1738–1820), who has been considered the father of American art. He was born of Quaker parents in Springfield, Pennsylvania, and his early training in art, he said, was from American Indians. But his real training began when he moved to Europe in 1760, settling in London three years later. He became a renowned painter of classical and historical scenes, exhibited no fewer than 258 works at the Royal Academy and succeeded Sir Joshua Reynolds as President in 1792. In this work, Isaac's wife Rebecca is depicted having given birth to her twin sons, proudly being displayed to their father. According to primogeniture, Esau, the firstborn, should have taken precedence over Jacob, which led to the well-known rivalry in the Old Testament story.

Occasionally, the splitting of a single fertilized ovum is not complete and results in conjoined or Siamese twins. Presumably because of its sensational interest, this has attracted more attention from some artists. Possibly the earliest depiction of conjoined twins is the case of the Chulkhurst Sisters of Biddenden in Kent, who (at least according to local tradition) were born in 1100 and lived to the age of 34.

Nowadays, interest in twins has been reawakened as it provides a natural experiment for studying the role of genetic and environmental factors in multiple sclerosis, diabetes mellitus and other relatively common conditions.

Multiple births can present a serious challenge to an obstetrician: the chances of survival of the babies are less and the risks to the mother are greater. Artificial stimulation of ovulation as an approach to female infertility can result in multiple births. As with *in vitro* fertilization, much research is therefore now focusing on methods for producing fewer good ova for fertilization in these women.

Esau and Jacob Presented to Isaac (c 1780) by Benjamin West. Oil on canvas, 182.9 cm × 513.1 cm. Greenville, South Carolina, Bob Jones University collection.

24

Self Portrait (1932)

by Dick Ket

Artists have occasionally either wittingly or unwittingly revealed in their self-portraits features that indicate signs of a medical condition. An excellent example is that of the Dutch painter, Dick Ket (1902–1940). From birth, he was diagnosed as having a serious heart defect and was not expected to survive childhood. He did, however, and went on to study at the School of Arts and Crafts at Arnhem. At first, he painted outdoor scenes, but as his symptoms of breathlessness and exhaustion increased, he turned more to working indoors on still-lifes and particularly self-portraits. At the Gemeentemuseum in Arnhem, which houses many of his works, it is possible to trace the gradual deterioration in his condition. He died at the early age of 38 in 1940.

It is now thought that he probably suffered from the condition referred to as Fallot's tetralogy (with dextro-cardia), characterized by pulmonary stenosis, ventricular septal defect, overriding aorta and right ventricular hypertrophy. This disorder accounts for around 10% of congenital heart disease. It was apparently first mentioned by the Danish anatomist Niels Stensen (of Stensen's duct) in the 17th century, and was described in detail in 1888 by the French physician Etienne-Louis Arthur Fallot (1850–1911).

In this self-portrait, there are clear manifestations of severe congenital heart disease: cyanosis and plethora, finger clubbing, and a bowl tinged with blood-stained haemoptysis. Ket is seen here exposing the right (a mirror image) side of his chest – perhaps because of his awareness of the forceful beating of his heart in this region. Incidentally, several of his portraits, as well as one with his father, include the image of a toy horse, which apparently refers to the meaning of the family name in Dutch.

There was no effective treatment until a surgical shunt operation was introduced in the mid-1940s and later extended to include repair of the various defects in the condition.

In many cases of serious congenital abnormalities, including Fallot's tetralogy, the cause is multifactorial, with both genetic and environmental factors being responsible. A variety of environmental factors have been identified over the years. For example, in some congenital abnormalities, the environmental factor has been identified as maternal alcohol consumption. In other defects, various drugs used in the treatment of epilepsy are responsible. Thalidomide was an excellent sedative, but was withdrawn in the early 1960s because it resulted in serious limb deformities in the fetus. Spina bifida is now known to result from a deficiency of folic acid in the mother's diet during pregnancy, and certain maternal infections can also cause fetal abnormalities, most notably rubella and congenital heart defects. Teratology, or the identification and study of possible causative factors in congenital abnormalities, is an active field of research nowadays and offers the potential for prevention.

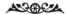

Self Portrait (1932) by Dick Ket. Oil on canvas, 80.5 cm × 54 cm. *Rotterdam, Museum Boijmans Van Beuningen.*

26

Inn Scene (early 1650s)

by Gerard ter Borch

The effects of excessive alcohol intake during pregnancy were first studied by William Sullivan as long ago as 1899. But it was only in the 1970s, after much research, that the real extent of the effects on the unborn child became fully appreciated – this increase in interest perhaps reflecting the growing prevalence of alcoholism in the general population.

The resultant syndrome, named fetal alcohol syndrome, is quite variable and includes a range of physical, mental and behavioural problems. There is some uncertainty about the actual level of alcohol consumption during pregnancy that may produce the syndrome, but even mild to moderate ingestion may be harmful. Even small amounts of alcohol can result in low birth weight, as can smoking cigarettes in late pregnancy.

The social consequences of excessive alcohol consumption are not a recent problem and have been depicted by a great many artists over the years, most notably William Hogarth in his renowned *Gin Lane* (1750–1751). Henry Fielding, a writer friend of Hogarth's, referred at the time to 'This odious vice' and goes on 'What must become of the infant who is conceived in Gin, with the poisonous Distillations of which it is nourished both in the womb and at the Breast'.

This great painting by the Dutch master Gerard ter Borch (1617–1681) shows a young lady drinking wine while her male companion appears to have already succumbed to its effects. At this time, a woman drinking undiluted wine in this way would have been regarded as shameless, even sinful.

In a very similar painting by the artist some 10 years later, the model was the artist's half-sister Gesina, who, after an unhappy love affair, wrote in her diary that unrequited love can only be soothed by the powers of wine. Disappointments in life, stress and overwork all contribute to excessive alcohol consumption. Furthermore, young girls under the influence may be less likely to practice safe sex. The Dutch have very recently launched a serious campaign against drinking, especially among young women. Apart from any other considerations, any unborn child is at risk of serious developmental abnormalities.

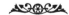

Inn Scene (early 1650s), by Gerard ter Borch. Oil on canvas, 34.5 cm × 27.5 cm. *Montpellier, musée Fabre, Montpellier Agglomération.* © Photo Frédéric Jaulmes.

27

A Child of Non-Disjunction (1971)

by Josef Warkany

There is no reason to believe that Down's syndrome has not been with us from the earliest times. Some have suggested it may have been portrayed in certain paintings, for example by Jordaens and Reynolds, and even by Mantegna in 1454 and on an Aachen altarpiece of 1505. But this is purely conjectural, since it is difficult to diagnose the disorder from external appearances alone. This work is by Josef Warkany (1902–1992), who was himself a renowned paediatrician and therefore there is no question of the diagnosis. It is taken from his monumental review, *Congenital Malformations; Notes and Comments*, published in 1971. Warkany was a much-respected paediatrician with a worldwide reputation for his work on congenital anomalies, and was the first recipient of the March of Dimes Award for his scientific and medical achievements. He was also a talented artist.

Down's syndrome is relatively common, with an overall incidence of around 1 in 700 newborns, although this is higher in infants born to mothers over the age of 35. Despite this, it was only clearly and comprehensively described in a short paper in the *London Hospital Reports* of 1866 by a then medical superintendent of an Asylum, John Langdon Haydon Down (1828–1896). But his report was ignored and unappreciated for several years and, to present eyes, clouded by the associated appellation 'mongolism'. However, by the end of the 19th century, the condition had become recognized and universally accepted as a distinct clinical entity.

Notwithstanding this, there could sometimes be confusion over the diagnosis in a newborn baby. This was only settled in 1959, when it was shown by the French cytogeneticist Jerome Lejeune and colleagues that cases of Down's syndrome had 47 chromosomes due to an extra chromosome 21: so-called trisomy 21. Cytogenetic studies could therefore confirm the clinical diagnosis. Subsequently, apparently milder cases were found to be chromosome mosaics, with some cells having a normal chromosome complement and others having an extra chromosome 21. Rare familial cases could also be explained by appropriate cytogenetic studies.

In the last few years, various prenatal diagnostic tests have evolved for determining the likelihood of a fetus having Down's syndrome. Such tests can be offered to older mothers, who may then choose to have the pregnancy terminated. But this remains a very contentious issue to many, and will probably remain so until the day ever comes when primary prevention is possible.

"A Child of Nondisjunction" Warkany

A Child of Non-Disjunction (1971) by Josef Warkany. Etching, 17 cm × 13.5 cm. *From*: Congenital Malformations; Notes and Comments, *Chicago: Year Book Medical Publishers, 1971.*
Reproduced with kind permission from Elsevier. © 1971 Mosby.

28

Mrs Dempster with Russell (c 1975)

by Robert Lenkiewicz

Cerebral palsy has been defined as motor impairment resulting from non-progressive brain damage. Most cases have little genetic basis and have their origin in the perinatal period. Birth injury has been virtually eliminated by improved obstetric practices, and nowadays prematurity with low birth weight accounts for many cases. Current research is also focusing on the possible role of viral infections. The clinical picture varies considerably, some children being relatively little affected while at the other extreme some may suffer from paralysis of all four limbs and also have some degree of mental handicap.

Possibly one of the best known paintings of the condition is the one by Jusepe de Ribera entitled *The Clubfooted Boy* (1642). But close inspection reveals that the boy in the work perhaps has cerebral palsy with a right spastic hemiplegia. In this more recent work by Robert Lenkiewicz, *Mrs Dempster with Russell*, there are no disease details, but it formed part of the artist's *Mental Handicap Project* and from the appearance of the child he may also have had cerebral palsy. In this project, Lenkiewicz painted no less than 480 children and adults with varying degrees of mental handicap.

Robert Lenkiewicz was born in London in 1941, the son of Jewish refugees. As a child, he already showed considerable painting ability and later trained at St Martin's College of Art and Design and later the Royal Academy. In 1964, he moved to Lanreath in Cornwall and then to Plymouth, where he settled and had a large studio and library. The studio became a magnet for vagrants and street alcoholics, who then sat for his paintings. They formed the basis of his *Vagrancy Project*, which was subsequently followed by other projects such as *Mental Handicap*, *Old Age*, *Death and Suicide* and *Addictive Behaviour*. In all these works, as well as in many others, Lenkiewicz clearly recognized and portrayed the sense of isolation often felt by the subjects. He has caught the sadness and feeling of impotence of the mother in this work.

Lenkiewicz was a very remarkable and talented artist who died suddenly in 2002 at the comparatively early age of 61. Up until the year before his death, he had continued to provide a free Christmas dinner for the homeless in a local bus station.

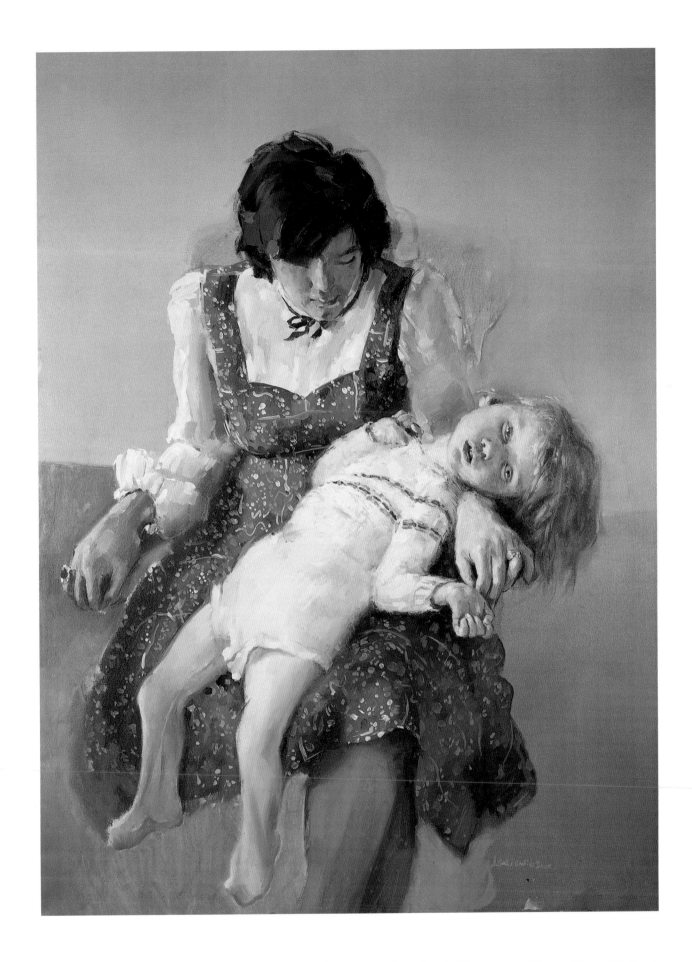

Mrs Dempster with Russell (c 1975) by Robert Lenkiewicz (Project: Mental Handicap). Oil on canvas, 122 cm × 91 cm. *UK, Private Collection.*
© The Estate of Robert Lenkiewicz. © Photo Derek Harris. Edited by White Lane Press.

29

Madonna and Child (c 1480)
by Carlo Crivelli

The close relationship between mother and child has been the subject of countless works of art from earliest times. The attraction to the artist is obvious. Very often, particularly in Renaissance art, such works featured the Madonna and Child. It has been estimated there are over a thousand such images as objects of veneration and worship. Many are spectacularly beautiful in their own right, such as Raphael's *The Madonna of the Granduca* (c 1506). Carlo Crivelli (fl 1457–1493) was born in Venice, son of the painter Jacobo Crivelli, and after receiving early training in Venice, moved to Padua for further study. His painting is characterized by flat space and precise, clean drawing of the faces. To the modern viewer of this work, painted in 1480, the Madonna seems somewhat cold and aloof, and both she and the infant Jesus are most concerned about the insect in the foreground.

Some have suggested that the fruit and fly are symbols of sin and evil. After all, in 1457, Crivelli had been sentenced to six months imprisonment for kidnapping a sailor's wife and thereafter left his native Italy, only returning some 10 years later. But could this be more than a devotional work? There is another possible explanation – perhaps more intriguing to doctors.

The Black Death had swept Europe in the 14th century and was still widespread when Crivelli produced his masterpiece. The plague had killed over 25 million people, and in some regions over a third of the population had perished. Miasma, dirt and flies were often associated with the disease, and perhaps this is reflected in Crivelli's painting.

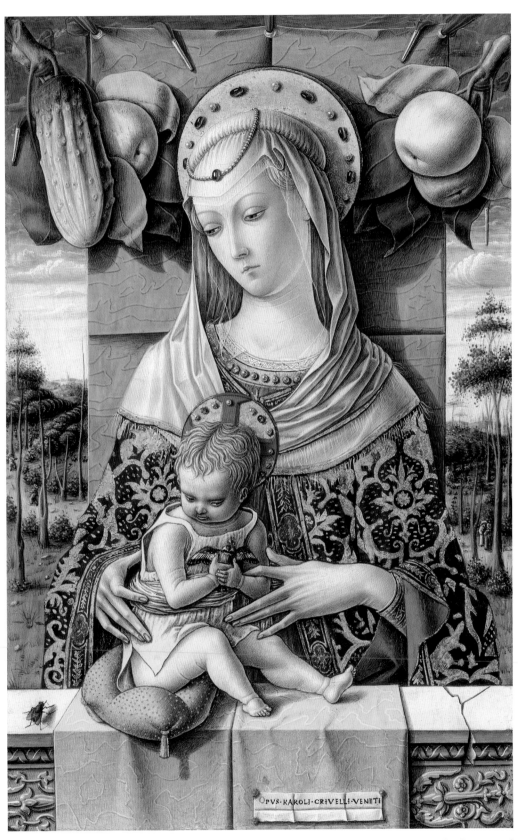

Madonna and Child (c 1480) by Carlo Crivelli. Tempera and gold on wood, 36.5 cm × 23.5 cm. *New York, The Metropolitan Museum of Art, The Jules Bache Collection, 1949 (49.7.5).*
©Photo 1984, The Metropolitan Museum of Art.

30

The Cradle (1872)

by Berthe Morisot

The Impressionist movement is usually dated from a Paris exhibition of 1874. The exhibition included Monet's *Impression: Sunrise*, which prompted journalists to dub the whole group exhibiting as 'Impressionists', coined in derision but later accepted by the artists themselves. But the group was not homogeneous in their approach to their art, different artists giving prominence to different aspects. The artists associated with the movement included, among others, Monet, Sisley, Renoir, Cezanne, Manet and Degas. Their ambition was to capture the immediate visual impression of contemporary experiences. This is clearly evident in this delightful work by Berthe Morisot (1841–1895). She was the daughter of a top civil servant and the niece of Fragonard, a much admired rococo painter of the 18th century, and was brought up in a highly cultured atmosphere. From an early age, she showed considerable promise in her art, and in 1868 Manet was introduced to her and her sister during a copying session at the Louvre. It is recorded that he wrote afterwards 'The demoiselles Morisot are charming. Too bad they are not men.' She soon sought Manet's advice and help, and it seems that she persuaded him to paint in the open air (*plein air*).

She was very beautiful, and often posed for Manet. But after marrying Manet's brother Eugène in 1874, she never sat for him again, although they remained good friends. In 1878, at the age of 37, she gave birth to her daughter Julie, to whom she was always very close. She nursed Julie through a bad attack of influenza in 1895, contracted it herself and died still only 53.

This painting is of Berthe's sister Edma nursing her second child Blanche, born a year previously. The baby lies peacefully asleep in a beautifully veiled crib, with mother looking on with wonder and affection. There can be very few paintings of a mother and child to match this peaceful, intimate scene executed by such a very talented artist. It has rightly been described as a great icon of modern maternity.

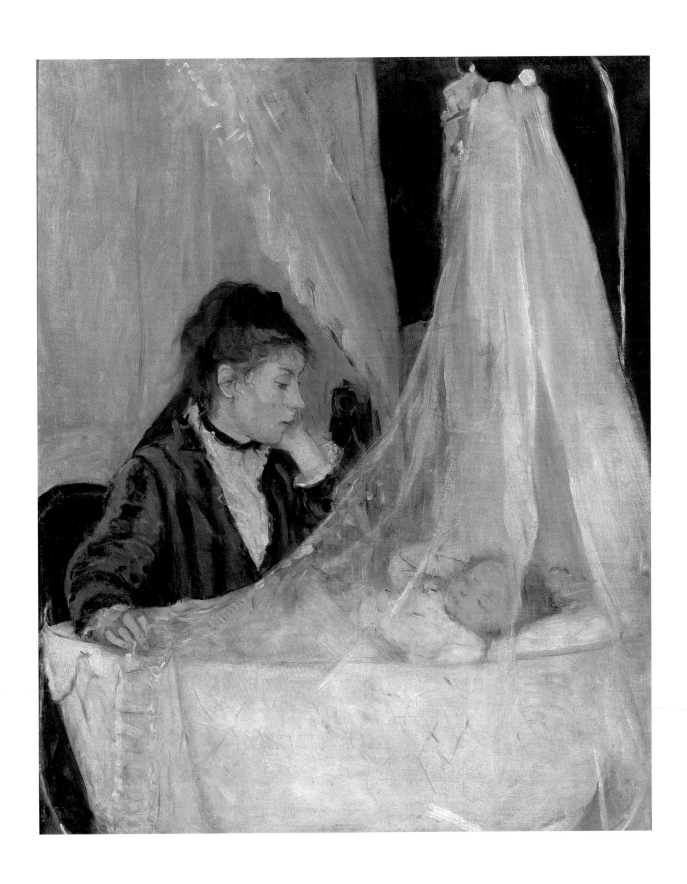

The Cradle (1872) by Berthe Morisot. Oil on canvas, 56 cm × 46 cm. *Paris, musée d'Orsay.*
©Photo RMN/© René-Gabriel Ojéda

31

Mother and Child (1924)

by Eric Gill

Over the years, artists have approached the subject of Mother and Child in very different ways. Many, particularly in the Renaissance, were most concerned with the devotional aspect of the Madonna and Child. Later it became a fashionable subject for oil painting. This wood engraving by Eric Gill (1882–1940) is yet another approach to the subject and very different in technique.

Eric Gill was a master craftsman: a renowned sculptor, wood engraver, letter cutter or typographer. His work can be seen, for example, in New College Chapel, Oxford, Westminster Cathedral, and the *Prospero and Ariel* group in Broadcasting House.

Gill was born into a missionary family – according to one biographer, '… a household in which admonition and instruction were almost second nature'. His paternal grandfather and great uncle were both missionaries, and later two of Eric's brothers were to follow in their footsteps and a sister became a Church of England nun. His father was also a clergyman. Eric remained a fervent Christian throughout his life, although at times somewhat unorthodox and eccentric. He was brought up as a Protestant, but aged 31 he converted to Catholicism. It is therefore understandable that much of his work should centre on subjects often related to his religious convictions.

Mother and child was a subject of many of his sculptures and engravings. There is also a remarkable pen and ink work of a Madonna and Child. The illustration here is a wood engraving. The technique is comparable to a woodcut, but in this case hardwood is used. This gives a harder, smoother surface, which is cut with a burin, resulting in a print with finer detail than a simple woodcut. This was one of a selection collected together by Douglas Cleverdon in 1929. The revealing tender relationship between mother and child is very striking despite the simplicity of this small work.

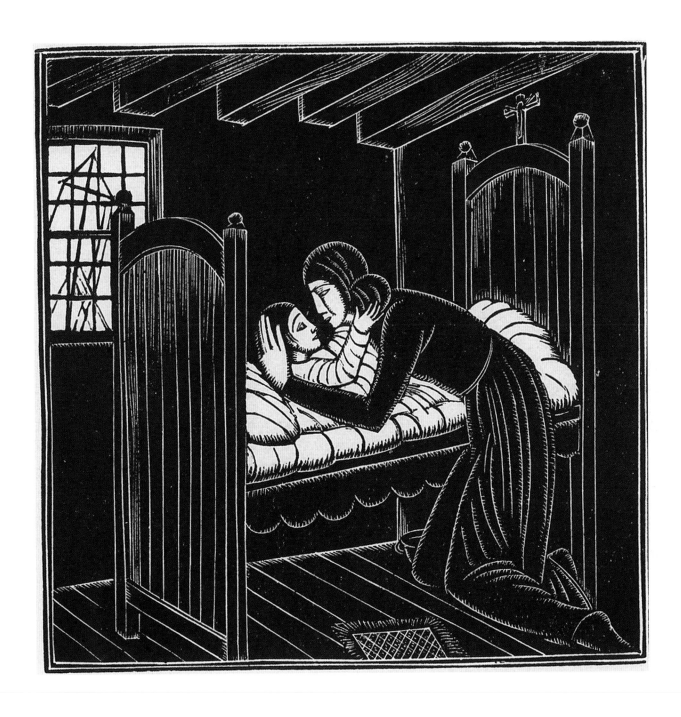

Mother and Child (1924) by Eric Gill. Wood engraving, 8.2 cm × 8.5 cm. *Author's collection.*
© The Bridgeman Art Library, London.

32

Detail from Orphrey (late 14th century)

anonymous, English embroidery on High Mass vestment

This illustration is a detail from an orphrey, a richly embroidered border on an Italian dalmatic, an ecclesiastical vestment worn by a bishop, cardinal or even a pope. English mediaeval embroidery at this time in the 14th century was famous throughout Europe. The embroidery features scenes from the early life of the Virgin, and this particular vestment is said to have been made for the Cistercian abbey of Whalley in Lancashire.

In this illustration of Mary and Joseph, their son Jesus is attempting to walk with the aid of what we might now refer to as a baby walker. The expressions of the parents and the arrangement of their hands and arms suggest their concern and delight at their son's attempts to walk, an experience many parents both then and now would identify with.

Development is a continuous process from birth to adulthood, and progression through these stages is a very important way of assessing a child's intellectual and physical state. Specialists in childhood disorders have studied and tabulated developmental 'milestones' in many normal children, and comparison with the findings in a particular child can play an important role in diagnosis.

For example, most children say two or three words with meaning by a year, and almost all normal children walk unaided by 18 months. In comparison, in the case of Duchenne muscular dystrophy, for instance, only about a half of boys who will later develop the disease are walking by 18 months, and they are never able to run properly.

But in all such assessments and tests, the ways in which they are interpreted and used in a particular case is very much a matter of clinical judgement.

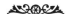

Detail from Orphrey (late 14th century), anonymous. English embroidery panel, 35 cm × 17 cm. *Glasgow, Glasgow City Council (Museums), the Burrell Collection.*

33

The Family of the Stone Grinder (c 1653–1655)

by Gerard ter Borch

Even today, head lice can be found in many schoolchildren, especially when personal cleanliness is poor. This often results in irritating pruritus, and can lead to secondary bacterial infection if not treated. A number of preparations are available for treatment, but in the past combing out the lice and eggs ('nits') was the only method possible.

The practice was depicted in the work of several genre painters of the 17th century. The Dutch artist of this work, Gerard ter Borch (1617–1681), was extremely talented and highly precocious. His earliest drawing, now in the Rijksmuseum in Amsterdam, is dated 1625, when he can have been only eight years old. Later, he became renowned for his paintings of interiors and portraits of elegant society. This work is a little different. But, like many works of the period, there is sometimes more implied meaning than is at first apparent.

The work depicts the courtyard of a poor family of a stone grinder, who lies on a plank sharpening a scythe on a large grindstone. Some critics have suggested this could have amorous and moral implications. A woman sits by a doorway and is engaged in combing a child's hair. This, it has been suggested, is emblematic of purging the soul. In the literature of the day, combs were seen as being symbolic of both virtue and vice. In an illustration of a comb in a book of emblems published in Amsterdam in 1614, it is labelled *Purgat et ornat*: cleanse (i.e. virtue) and adorn (i.e. vanity). In the background is a tall gabled building, its roof surmounted by a stork's nest. According to classical writers and mediaeval bestiaries, it was believed that the stork fed its parents when they were no longer able to care for themselves, and hence the bird came to symbolize filial piety.

Of course, all this could be mere conjecture and speculation. It could well be that what we see is merely the artist's straightforward impression of a typical poor working family of the day.

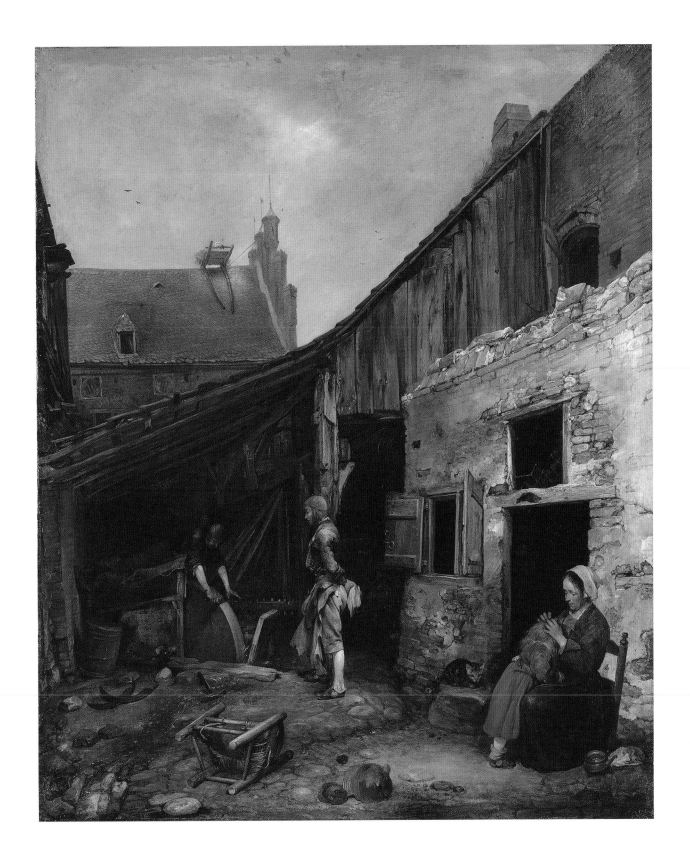

The Family of the Stone Grinder (c 1653–1655) by Gerard ter Borch. Oil on canvas, 72 cm × 59 cm. *Berlin, Gemäldegalerie, Staatliche Museen.*
© Photo Jörg P. Anders.

34

Foundling Girls in their School Dresses at Prayer in the Chapel (c 1877)

by Sophie Anderson

In the past, to have a child out of wedlock was considered shameful and contemptible – well illustrated in the character of Lady Dedlock in Charles Dickens' novel *Bleak House*.

The social stigma could force a mother to abandon her infant to a parish poorhouse or workhouse, where they often died from neglect. This situation led to the formation of various charitable organizations to care for these children, such as Barnardo's Homes and the Thomas Coram Foundling Hospital. The latter was established by Captain Thomas Coram (1668–1751), who was born in Lyme Regis and went to sea before he was 12 years old. He sailed to the USA, where he settled into business and married, returning to England in 1719. The stimulus to set up the Foundling Hospital was his shock at the sight of so many abandoned babies and young children in Georgian London. In his efforts to find financial support, he enlisted the help of his friend the artist Hogarth. Another distinguished early benefactor was the composer Handel. In fact, the Foundling Hospital became a centre for artists out of which the Royal Academy developed. From its founding charter in 1739, it aimed to rescue the most needy children. They were educated and brought up on Christian principles until age 14, when boys were sent into the army and girls into domestic service.

The Foundling Hospital has evolved over the years, but continues today to provide free services for children and families of the local community, incorporating care, education and support along with creative arts linking back to its early beginnings.

This painting of *Foundling Girls* is by Sophie Anderson (1823–1903), who was the daughter of a French architect and an English mother. She was born in Paris, where she later studied art. Following the revolution of 1848, she left for America, married and established herself as a successful portrait painter. She and her husband came to England in 1854, where she became well known for her genre paintings of domestic scenes, with a particular talent for portraying children. She exhibited at the Royal Academy from 1855 to 1896. Her work was much admired by Lewis Carroll, who bought several of her paintings.

The girls in the painting are dressed appropriately for their future domestic service, and the artist has caught very well the quiet contentment of these little girls in Chapel – a very far cry from the street children outside.

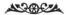

Foundling Girls in their School Dresses at Prayer in the Chapel (c 1877) by Sophie Anderson. Oil on canvas, 67.3 cm × 53.5 cm. *London, Foundling Museum/The Bridgeman Art Library.*
© Coram Family in the care of the Foundling Museum.

35

The Captured Truant (1850)

by Thomas Brooks

In Britain, the earliest schools were the free grammar schools, probably the best known being Manchester Grammar School, founded by the Bishop of Exeter, Hugh Oldham, in 1515. These schools taught Latin grammar, from which their name was derived. Later, many of them became endowed public schools and essentially fee-paying, leaving the remainder as grammar schools in which tuition remained free.

These schools, however, were very much the exception. Up until the 19th century, most teaching resulted from local initiatives, and was the responsibility of perhaps a clergyman or an educated parishioner. In some cases, school meant little more than Sunday School where pupils could be taught the rudiments of writing and literacy in order at least to read the Scriptures. But otherwise the arrangements were *ad hoc* and often very poor. An 1834 survey in Manchester, for example, reported:

> 'The schools are generally found in very dirty unwholesome rooms – frequently in close, damp cellars, or old dilapidated garrets. In one of these schools eleven children were found in one small room … [they] squatted upon the bare floor there being no benches, chairs or furniture of any kind in the room.'

The teaching was equally poor, being carried out often by old men '…whose qualification for this employment seems to be their unfitness for every other.'

Thereafter, matters began to change, starting with Gladstone's Education Act of 1870, which was followed by others making education free and compulsory, eventually, with H. A. L. Fisher's Education Act of 1918, up to the age of 14. In the long term, improvements in education would no doubt have a favourable influence on health in general.

There are many works of art depicting children being taught. Some, such as Chardin's *The Young Schoolmistress* (c. 1736), emphasize the close relationship between a caring teacher and young pupil. Others depict all too clearly the depressing atmosphere of most early school rooms, as in this work by Thomas Brooks (1818–1891), who was born in Hull and exhibited at the Royal Academy over a 40-year period. He was influenced by the Pre-Raphaelites and became known for his marine subjects. This painting is clearly very different. The detail exposes the appalling conditions in children's schooling in 1850, before Parliament enacted important changes and improvements. The education debate continues even today.

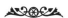

The *Captured Truant* (1850) by Thomas Brooks. Oil on canvas, 71.1 cm × 116.8 cm. *UK, Private Collection.*
© Christie's Images Ltd., 1975.

36

Le Médecin des Pauvres
(Doctor for the Poor) (1857)

by Jules Léonard

Many paintings of the 19th century that deal with poverty and sickness are nowadays often considered overly sentimental. This is perhaps true for example for Luke Fildes' *Applicants for Admission to a Casual Ward* (1874), but not for this work by Jules Léonard. Léonard was born in Silenrieux, Belgium in 1827, but lived many years in Valenciennes, France, where he was known as a genre painter and where he died in 1897.

Utter hopelessness is reflected in the central figure of a workman cradling his son, who appears to have injured his head, and the little girl by their side also shows concern. This misery is shared by a seated figure on the right with his head in his hands. The girl on the left, having her pulse taken, is clearly grossly anaemic. It is, all-in-all, a scene of desperation and despondency. The queue waiting to see the doctor extends out through the open door of his surgery.

The poor in society could rarely afford a doctor's fee, although he often had little to offer in the way of effective treatments. In Britain in 1911, however, the government launched the National Insurance Scheme whereby, with a small weekly contribution from the individual coupled with contributions from the State and employer, the more poorly paid would be guaranteed to receive free medical treatment from a 'panel' doctor. This, Roy Porter has argued convincingly, helped cement a lasting and valued relationship between the sick and their GPs, secured by the authority of the State. The scheme would be reinforced with the establishment of the National Health Service in 1948. Despite all the vicissitudes and criticisms of our present Health Service, it is a very far cry from the situation illustrated in this revealing painting of 1857 by Léonard.

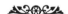

Le Médecin des Pauvres (*Doctor for the Poor*) (1857) by Jules Léonard. Oil on canvas, 97.3 cm × 147.5 cm. *Valenciennes, musée des Beaux-Arts.*

©Photo RMN/© René-Gabriel Ojéda.

37

Roma Making an Offering to Astarte (c 1400 BC)

anonymous, funerary stele

Of the many diseases that must have afflicted people in the past, records rarely provide sufficient detail to be able to make a specific diagnosis. Even the nature of the plague of Athens in 430 BC, which was well documented by several writers at the time, most notably Thucydides, is not at all clear. There is, however, one condition depicted in Ancient Egypt where the diagnosis seems clear. This is the case of Roma, who was a doorkeeper of around 1400 BC and is portrayed on his funerary stele. He clearly has a grossly wasted and shortened leg with an equinus deformity of the foot. It seems most likely that he had poliomyelitis.

There have been several written descriptions in the past of what may have been poliomyelitis, but it was only in the 19th century that the diagnosis became clear of what at the time was thought to be a new disease. Subsequently in 1905, it was shown to be infectious and in the 1930s to be caused by a virus.

Acute anterior poliomyelitis, or infantile paralysis, has on occasions reached epidemic proportions. Over 50 000 people a year were affected in the USA and President Roosevelt was crippled by an attack in 1921. In Britain, Sir Walter Scott's lameness was attributed to the disease and a major outbreak occurred in the late 1940s. Vaccines, however, became available in the 1950s, first with the Salk vaccine by injection, later superseded by the Sabin vaccine taken by mouth.

The widespread use of the vaccine has virtually eradicated the disease in the USA and Western Europe. However, it persists in many Third World countries. Since the virus can only survive in human hosts, the hope is that it may be eradicated entirely by an intensive campaign of immunizing everyone throughout the world – currently a real and very important aim of the World Health Organization. Meanwhile, it has more recently been reported that some individuals who recovered from the acute phase of the disease may experience new or increased symptoms many years later. This so-called 'post-polio syndrome' is now a further topic of intense research to determine why it occurs in some individuals but not others.

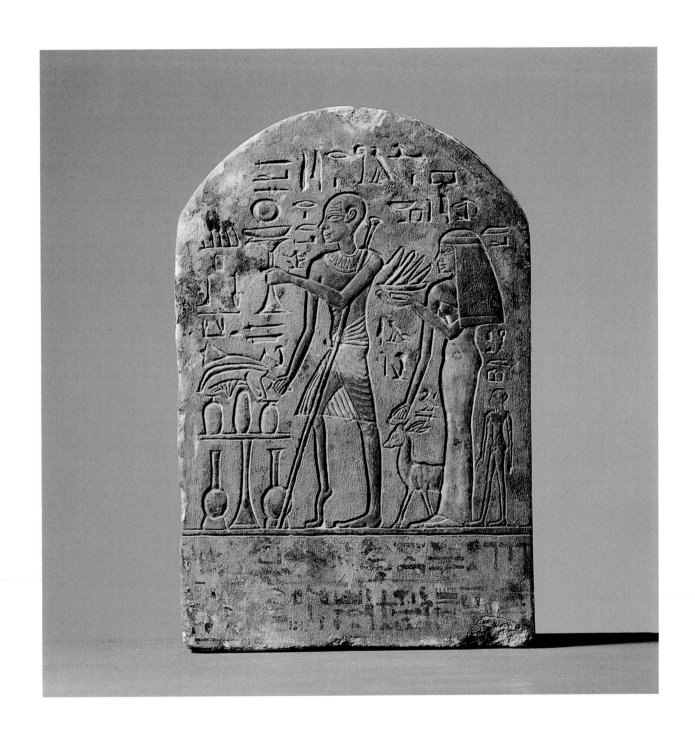

Roma Making an Offering to Astarte (c 1400 BC) anonymous. Funerary stele. *Copenhagen, Carlsberg Glyptotek.*
© Photo Ole Haupt.

38

Inheritance (1903–1905)
by Edvard Munch

According to the Old Testament, the sins of the father may pass to his children, even to the third and fourth generation. Some have interpreted this painting as showing a nursing woman with syphilis who has transmitted it to her infant.

In Western Europe, syphilis has been present since at least the 15th century and reached epidemic proportions very early on. The London surgeon William Clowes estimated in 1579 that no less than three out of every four patients admitted to St Bartholomew's Hospital suffered from the disease. The artist William Hogarth depicted the disease in various works, and even indicated the transmission of the congenital form in *Marriage-à-la-Mode VI* (1743).

The manifestations in an infected infant can include 'saddle nose', various skin eruptions, bone involvement and deformed teeth (so-called Hutchinson's teeth), as well as other abnormalities.

This painting is by the Norwegian artist Edvard Munch (1863–1944), who had painted a similar work with the same title some six years previously. Around the time this work was painted, syphilis and its congenital form were very much in everybody's mind in Norway – as dramatically portrayed for example in Henrik Ibsen's play *Ghosts* (1881). Munch himself also called this painting *The Syphilitic Child*, but the diagnosis has recently been questioned. It has been suggested that it may in fact represent a genetic condition, perhaps a dominantly inherited skin disorder such as epidermolysis bullosa.

A clear distinction between congenital diseases that are acquired as opposed to those which are inherited, the so-called nurture-nature concept, was only becoming clear at this time through the work of the pioneering geneticist Francis Galton (1822–1911). The precise nature of the genetic mechanisms involved followed the work of William Bateson (1861–1926) of Cambridge. In the early 20th century, he showed that the newly rediscovered ideas of Gregor Mendel could be applied to human inheritance.

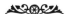

Inheritance (1903–1905) by Edvard Munch. Oil on canvas, 119 cm × 100 cm. *Oslo, Munch Museum.*

39

Vaccination by Edward Jenner Against Smallpox, 1796 (1879)

by Georges Gaston Théodore Mélingue

Smallpox has afflicted mankind from earliest times, one of the first epidemics of the disease being described by Eusebius in Syria in AD 302. Its ravages accompanied trade and colonial expansion, and went together with for example Cortés in his conquest of Mexico and Pizarro in his conquest of Peru.

The story of Edward Jenner (1749–1823), a Gloucestershire country doctor, and his introduction of vaccination has been well told. It had been known for some time that milkmaids infected with cowpox, a mild infection in humans, became immune to smallpox. Jenner proved that if he inoculated healthy individuals with cowpox material from an infected milkmaid, they were made immune to smallpox.

There have been many paintings depicting vaccination sessions, some in rural settings, such as Ernest Board's, others in more prosperous households, such as Louis-Léopold Boilly's. This work by Gaston Mélingue has been selected for two reasons. Firstly, it is by a French artist, whose country most enthusiastically pioneered vaccination from the very beginning, being promoted for example by Napoleon as well as the medical fraternity and the Church. Secondly, the painting uniquely illustrates a milkmaid from whom the material for vaccination has been obtained. She is seen bandaging up her arm on the right of the work. Georges Gaston Théodore Mélingue (1840–1914), although perhaps less known outside his native country, created several noted historical and genre paintings, including this work, which is perhaps one of his best.

The worldwide adoption of smallpox vaccination ultimately led to the global eradication of smallpox in 1979, two hundred years after Jenner's publication on the subject.

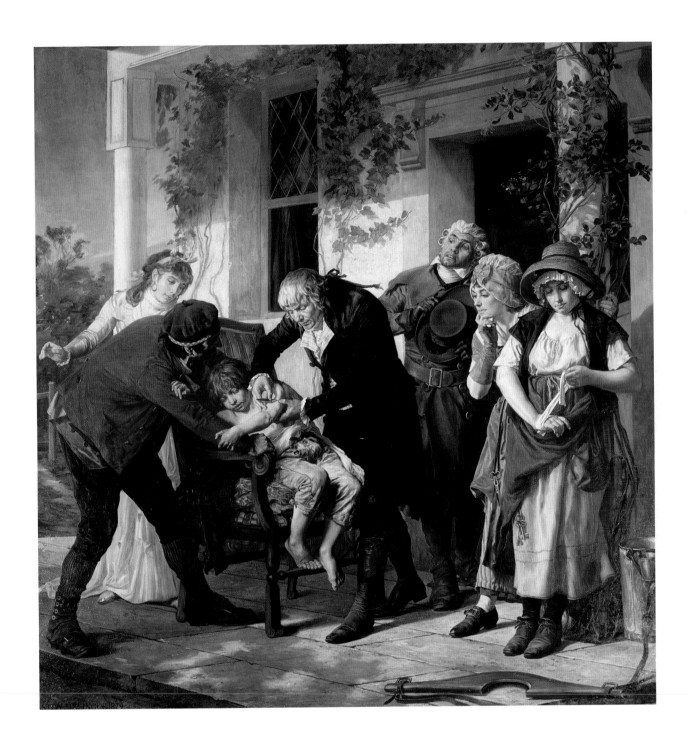

Vaccination by Edward Jenner Against Smallpox, 1796 (1879) by Georges Gaston Théodore Mélingue. Oil on canvas, 310 cm × 300 cm.
Paris, Academie Nationale de Médecine Archives Charmet, London, The Bridgeman Art Library.

40

Diphtheria, *or* Lazarillo de Tormes (1819)
by Francisco Goya

Francisco José de Goya y Lucientes' (1746–1828) career as an artist began rather inauspiciously. In fact, he did not begin to gain recognition until he was in his mid-30s and was elected to the Madrid Academy. From then on, his talent became increasingly recognized, and eventually he became Principal Painter to the King of Spain. A little later, at the age of 47, he developed a serious illness, probably viral, with temporary loss of balance, the right side of his body was paralysed, his eyesight was affected and he became deaf. Over the following months, he gradually recovered, although he remained deaf throughout the rest of his life. But the ordeal left a legacy: his art became particularly concerned with many morbid and macabre subjects, given expression for example in a series of engravings, *Los Caprichos* (1799). However, some of his later works do depict more conventional subjects, such as the *Family of Charles IV* (1800).

The painting was completed during this later period. Some have suggested that it represents a scene from the picaresque novel *Lazarillo de Tormes* depicting the extraction of a piece of food lodged in a boy's throat. Most, however, consider the painting to represent *Diphtheria*. The most serious early complication of the disease was obstruction of the upper airway by a membrane, and the Spanish originally entitled the work *El Garrotillo* for this reason. It is a vivid portrait of the physician holding the patient immobile while he probes deeply into the boy's mouth in an attempt to clear the airway. If this failed then the only resort would have to be intubation or even tracheostomy.

Diphtheria, along with scarlet fever, were common diseases with very high morbidity and mortality rates. In fact, diphtheria was the leading cause of death in young children in the industrial West until the introduction of immunization programmes beginning in the late 19th century and the Schick test in 1913 to detect those at risk.

Diphtheria toxoid is usually combined as a 'triple vaccine' with tetanus and pertussis, and there are also immunization programmes against measles, mumps and rubella (MMR). Most recently, pneumococcal meningitis has been included among serious diseases for which there is now a vaccine. In fact, in Britain, there are now vaccination programmes against ten infectious diseases of childhood.

In the case of diphtheria, such programmes have reduced the incidence significantly and it has now been virtually eliminated in Britain. There has, however, been a recent increase in incidence in the Russian Federation and Ukraine, which is causing concern.

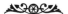

Diphtheria, or **Lazarillo de Tormes** (1819) by Francisco Goya. Oil on canvas, 80 cm × 65 cm. *Private Collection, Giraudon/Bridgeman Art Library.*

41

Playing at Doctors (1863)

by Frederick Daniel Hardy

In their play, children often enact situations involving those they see as exciting figures whom they wish to copy. Nowadays, this may centre on pop stars and other celebrity figures in the media. In the past, doctors and nurses often featured in such games, and it was a frequent and popular subject of many paintings in Victorian days. No doubt, this reflected the fact that doctors often saw their young patients at home surrounded by other members of their family, including the parents. All would no doubt be awed by the occasion, the doctor being held in great esteem at the time. This would be despite his being able to offer little in the way of diagnosis apart from what he would see and hear, and very few effective treatments were available. The doctor's skills centred very much on sympathetic understanding and, hopefully, reassurance. It would certainly make his visit to the home more appealing to his little patients than their visit to a hospital would nowadays, with all its technology and often forbidding appearance of medical attendants in their white coats.

The scene of playing doctors is delightfully depicted in this painting by Frederick Daniel Hardy (1826–1911). He was the son of a musician and actually trained for the same profession at the Royal Academy of Music. However, on completion of his studies, he was persuaded by his friends to relinquish music in favour of art. He soon became well known for his humorous scenes of children in domestic situations. He often included adults watching the children's world of play and make-believe as in this work. One of the children is taking the pulse, another is involved with a pestle and mortar, and yet another is pouring out medicine from a bottle. Other childhood toys lie abandoned and neglected in the foreground, playing doctors proving to be far more interesting!

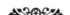

Playing at Doctors (1863) by Frederick Daniel Hardy. Oil on canvas, 35.3 cm × 44.8 cm. *London, Victoria and Albert Museum.*

42

The Sick Child (1885)

by Eugène Carrière

The theme of the 'sick child' has attracted many artists. For example, Pablo Picasso (1881–1973), not renowned for overly sentimental subjects, painted a very touching scene of a mother and sick child in 1903. This was during his so-called Blue Period when he chose subjects from among the poor and frequently social outcasts, and the mood was often melancholy, expressed through cold delicate blue tones. But this painting by the French artist Eugène Carrière (1849–1906) has been selected because he was particularly renowned for his intimate scenes of middle-class family life and had a special interest in the theme of motherhood, which, it is said, he treated with an almost mystical reverence.

In this large painting, which was exhibited at the Salon in 1885, the scene is painted in sombre colours; only the sick child stands out, emphasizing the focus of the work. Even the small dog seems to express hushed concern. Of the other two children, one is ready with a cup, perhaps of broth, and the mother or baby may have dropped something, which a younger child is attempting to retrieve.

Carrière's empathy for domestic scenes inspired the French novelist Edmond de Goncourt to refer to him as 'the modern Madonna painter'. This evolved from the artist's background and association with the Symbolist movement of the period, with an emphasis on dream-like sensitivity. He had a strong belief in the essential brotherhood of man, and considered his own family as a microcosm of mankind. He received many honours during his lifetime, becoming a Founder Member of the Société Nationale des Beaux-Arts and exhibited widely. He was very happily married with five daughters, but died at the early age of 57 from throat cancer. His legacy is a number of fine paintings of the home and family, many of which are in the musée d'Orsay.

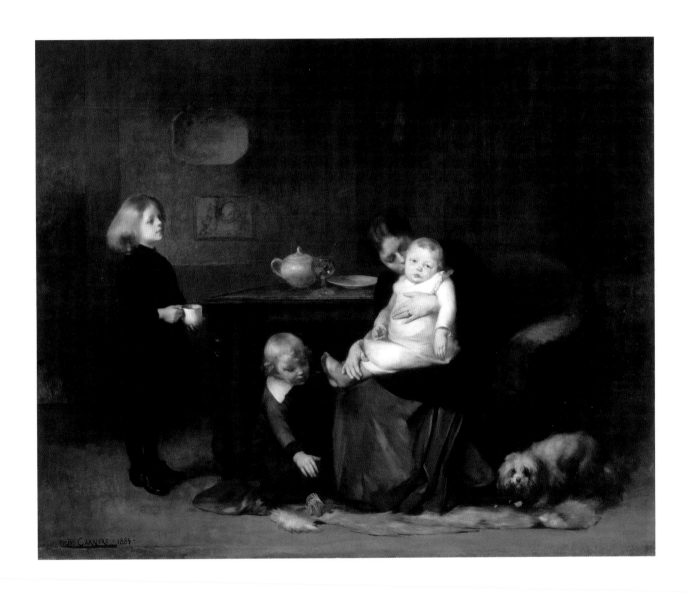

The Sick Child (1885) by Eugène Carrière. Oil on canvas, 200 cm × 246 cm. *Paris, musée d'Orsay.*
© Photo RMN/© Jean Schormans.

43

The Convalescent (1888)
The Convalescent (1945)
by Helene Schjerfbeck

Over the years, the 'Sick Child' and the 'Convalescent Child' have both attracted the attention of artists, but often the result has been a somewhat oversentimentalization of the subject. This cannot be said of the Finnish artist, Helene Schjerfbeck (1862–1946), who returned to the subject of a convalescent child many times during her long life, the first and last versions of the subject being separated by nearly 60 years.

From an early age, she showed great promise as an artist and attended art school in Helsinki. At the beginning of the 1880s, she was awarded a grant to travel to France to extend her studies. Later, she went to St Ives in Cornwall, which, like many artists of the time and later, she found particularly attractive, with its remote fishing villages, dramatic seascapes and excellent light. It was here that she painted the first version of the convalescent child. There is a hint, with the green budding branch, that the child is recovering – a tense time, particularly in the days before antibiotics and effective treatments for many childhood ailments. She has not in any way sentimentalized the subject: there is no prettiness.

The artist usually employed models for her work, but nothing is known of the subject of this work. Could it represent her own childhood? At the age of four, she fell downstairs, severely damaging her hip, and this injury thereafter very much restricted her activities to painting and letter-writing. It may be the explanation in this painting for the pencil, red pen wiper and bottle of ink on the table and the crammed bookshelf in the background.

The last painting of *The Convalescent* in 1945, completed the year before her death, is in watercolour. There is now little detail – emphasis is on the child's pale and colourless face. Modern viewers might well feel that it better reflects the sense of isolation and concern that a small child recovering from an illness might feel. According to the Catalogue of the work: 'Throughout her whole life, the most important thing to Helene Schjerfbeck was not what she painted, but how she painted.'

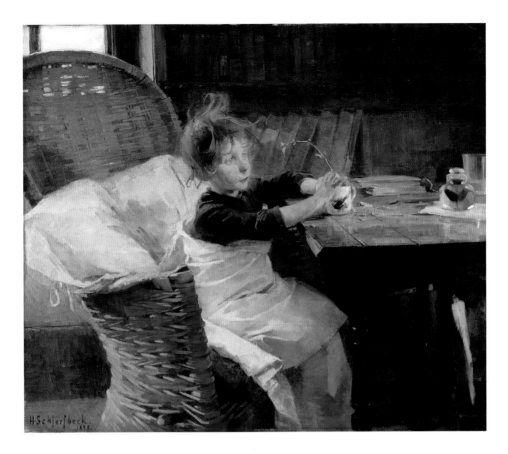

Upper figure: *The Convalescent* (1888) by Helene Schjerfbeck. Oil on canvas, 92 cm × 107 cm. *Helsinki, Ateneum Art Museum.*
© Photo Central Art Archives/© Hannu Aaltonen.
© DACS 2006.

Lower figure: *The Convalescent* (1945) by Helene Schjerfbeck. Watercolour, 41.5 cm × 51 cm. *Private Collection.* Photo courtesy of
Sotheby's Picture Library.
© DACS 2006.

44

Ivory Female Diagnostic Statuette (18th to early 19th century)

anonymous

A very real problem facing medical practitioners in previous times, and in some communities even today, is that of female modesty. Models, as in this Chinese ivory, were made use of so that a female patient could indicate to her doctor the location of her symptoms. Note that, as was the thousand-year-old custom in China, the model's feet have been bound. This resulted in compression of the arch and folding under of the toes, forming the 'Golden Lotus' – considered an ideal female attraction.

Apart from a history and inspection of the face and tongue, the most important diagnostic technique of ancient China, as well as in various other parts of the world (including the West), was feeling the pulse. The physician noted every detail and identified countless variations. In one treatise, *Muo-Ching*, numerous volumes were necessary to cover all these variations. Perhaps because pulse-taking was the mandatory single diagnostic test, female modesty would not be infringed. In the West, the American artist Winthrop Chandler (1747–1790) painted his brother-in-law physician taking the pulse of his female patient who is extending her arm from behind the privacy of a carefully curtained bed.

The problem was very real, however, in assessing an obstetric or possible gynaecological case. In his classic atlas, *Nouvelles Demonstrations d'Accouche-ments* of 1822, Jacques Pierre Maygrier shows a doctor kneeling before a standing fully clothed woman with his hand under her dress attempting to perform a vaginal examination. And when Queen Victoria died of a stroke in 1901, her long-time and trusted personal physician, Sir James Reid, who had never examined his patient's chest or abdomen, was surprised to discover she had had a ventral hernia as well as a uterine prolapse.

Gradually, examination of the female patient by a male practitioner became accepted – although, for the sake of etiquette and for legal reasons, it is customary nowadays for a female colleague also to be present at the time.

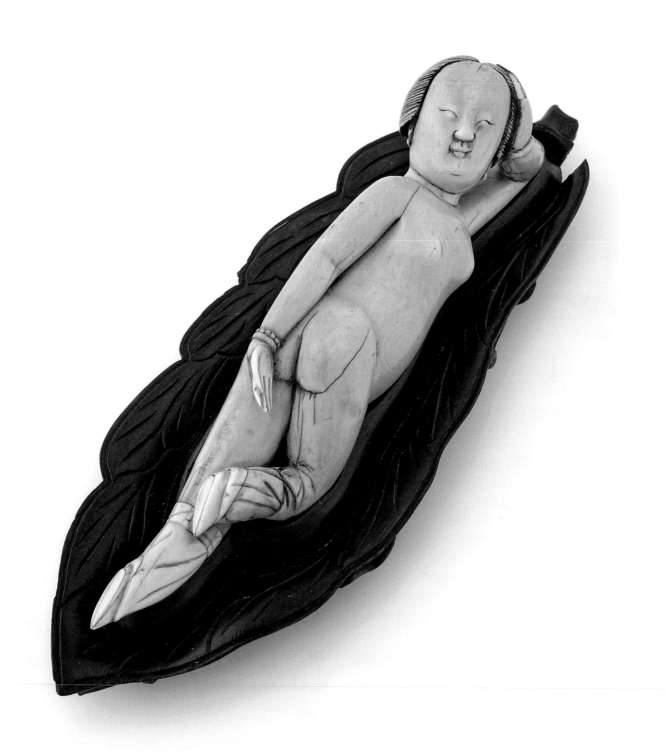

Ivory Female Diagnostic Statuette (18th – early 19th century), anonymous. *London, Wellcome Library.*

45

The First Ovariotomy (1878)

by George Kasson Knapp

Ephraim McDowell (1771–1830) is considered to be the founder of gynaecological surgery. He was born in America, but at the age of 22 went to Edinburgh to study medicine, returning in 1795 to settle in Danville, Kentucky. The story of the first successful removal of a large ovarian cyst by McDowell is now well known. The patient, a Mrs Jane Todd Crawford, in her 40s, journeyed some 60 miles to McDowell's home for the operation, which was carried out on Christmas day in 1809. During the operation, which took 25 minutes with no anaesthetic or antisepsis, Mrs Crawford recited psalms and hymns for comfort.

The tumour in total exceeded 10 kg, and was removed through the peritoneum. Mrs Crawford recovered fully, and rode home some three weeks later and lived for more than 30 years after this epoch-making operation. McDowell later went on to remove several more ovarian tumours, with, it is believed, only one fatality. There had been others who had punctured and aspirated ovarian cysts previously, such as Robert Houston (1678–1734) of Glasgow in 1701, but McDowell was the first to carry out a total ovariotomy, a term first introduced by Charles Clay (1801–1893) in Britain some years later.

This work is by a little known American artist George Kasson Knapp (1833–1910), who was essentially an engraver but in later life made a reputation as an artist. He was born on an Onondaga Hill farm and was an avid farmer throughout his youth. He began his career in art in 1858 when he began painting portraits, and also became known for his historical and landscape paintings. He became the first Professor of Painting at Syracuse University in 1873, and continued to paint for 50 years until his death from heart disease in 1910.

This was the earliest of George Kasson Knapp's historical paintings. The graphic detail shows the surgeon, Ephraim McDowell, suitably attired with an apron, assisted by colleagues, one of whom was probably his nephew, Dr James McDowell, holding down the patient. A bed is made up ready to receive the patient, and a coloured maid is seen entering on the right, this being a home in the Southern States of America. This work is comparable in its dramatic and historical importance to Robert Hinckley's *First Successful Public Demonstration of Surgical Anesthesia*, which was carried out at the Massachusetts General Hospital in 1846, nearly 40 years after McDowell's celebrated operation.

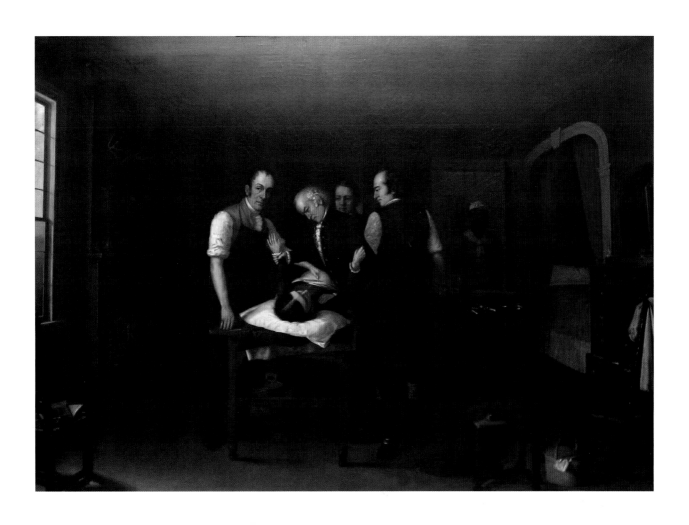

The First Ovariotomy (1878) by George Kasson Knapp. Oil on canvas, 129.5 cm × 172.7 cm. *Syracuse, New York, Onondaga Historical Association Museum and Research Center.*

46

The Village Doctress (1783)

by James Northcote

Women have played an important role in caring for the sick from the earliest times – at first in the West as nuns associated with religious orders and later as nurses in secular communities. Their skills were particularly sought in the care of children. However, it was not until the end of the 19th century that they were finally accepted for professional medical training and as qualified doctors.

There had always been strong opposition to women entering the profession. Women appearing before the Royal College of Physicians on a charge of practising medicine could be imprisoned or fined up to £20. In contrast, an unqualified male offender would only be fined 40 shillings. Women were forced eventually to found their own medical schools. In Britain, the London School of Medicine for Women (later the Royal Free Hospital) was opened in 1874 as a result of the pioneering efforts of Elizabeth Garrett (1836–1917) and Sophia Jex-Blake (1840–1913). In time, women were finally admitted to the most prestigious Schools of Medicine.

In Britain, the University of Edinburgh Medical School was the first to admit women students, although at the beginning they received instruction in separate classes. It was only in 1876 that an Act of Parliament empowered examining bodies to allow women to qualify with registration by the General Medical Council. Many years later, in 1909, the Royal College of Physicians changed its by-laws to allow women to sit examinations to become Licentiates and Members of the College and to become Fellows in 1925, although this was not implemented until nine years later. Interestingly, in 1934, the first woman to become a Fellow was an eminent paediatrician, Dr Helen MacKay. But it was many years later, in 1989, that the College elected its first woman President, Dame Margaret Turner-Warwick.

The subject of this 1783 work by the English artist James Northcote (1746–1831) predates all of these developments. At this time, the 'woman doctor', though often ridiculed by her male colleagues, was often welcomed by society if for no other reason than the practical need. Here she is depicted examining a young lady's hand. The original oil painting was exhibited at the Royal Academy in 1783, and has been in a private collection ever since. This reproduction of the original painting is a coloured mezzotint engraving by James Walker, engraver to the Empress Catherine the Great. James Northcote came from humble beginnings in Plymouth and could not read or write until he was 13. But he soon showed that he had artistic talent and went to London to become a pupil, assistant and biographer of his fellow Devonian, Joshua Reynolds. He was renowned for his history paintings, one of his best being *The Murder of the Princes in the Tower*, and as an author and biographer. The Northcote House at the University of Exeter is named after the family.

The Village Doctress (1783) by James Northcote. Mezzotint, with watercolour and gouache, 51.5 cm × 40.6 cm. *London, Wellcome Library.*

47

The Examination (1892)

by Imre Knopp

This work is by a lesser known Hungarian artist Imre (or Emerick) Knopp (1867–1945), the son of József Knopp, also a painter. He was a realist genre painter who studied in Weimar and Paris, and, after returning to Budapest in 1892, concentrated on portraits and conversational pieces. He was influenced by the *plein air* painters after a trip to Holland, and began to use lighter and brighter colours. Several of his paintings are now in the Hungarian National Museum. In this 1882 painting, he shows a child in hospital being examined by a doctor. This was around the time that medical specialities were developing, including the provision of paediatric hospitals. In Britain, the Hospital for Sick Children in Great Ormond Street in London was founded by Charles West (1816–1898) and opened in 1852. Thereafter, there was an expansion of children's hospitals throughout the country.

There had, however, been a growing interest in the subject of children's illnesses for some time. In 1784, Michael Underwood (1736–1820) had brought out his influential *Treatise on the Diseases of Children*. Others followed, and the first Professorship of Childhood Diseases was established in Vienna in 1884. These developments resulted from the recognition of the appalling infant mortality rates, around 150 per 1000 live births (compared with a figure of five nowadays), coupled with developments in medical science that began to offer the possibilities of better diagnosis and treatment.

In Britain, among the earliest established Professorships in Paediatrics were those at King's College Hospital, London with Sir George Frederic Still and at the University of Newcastle with Sir James Spence.

The speciality of Paediatrics has mainly been the province of men. In an authoritative review in 1999, of those who had made significant contributions to the subject in the 20th century, only 13 out of 268 listed were women. But the situation is changing, and increasing numbers of women doctors are now being attracted to the speciality of Paediatrics, although fewer are being attracted to Obstetrics and Gynaecology.

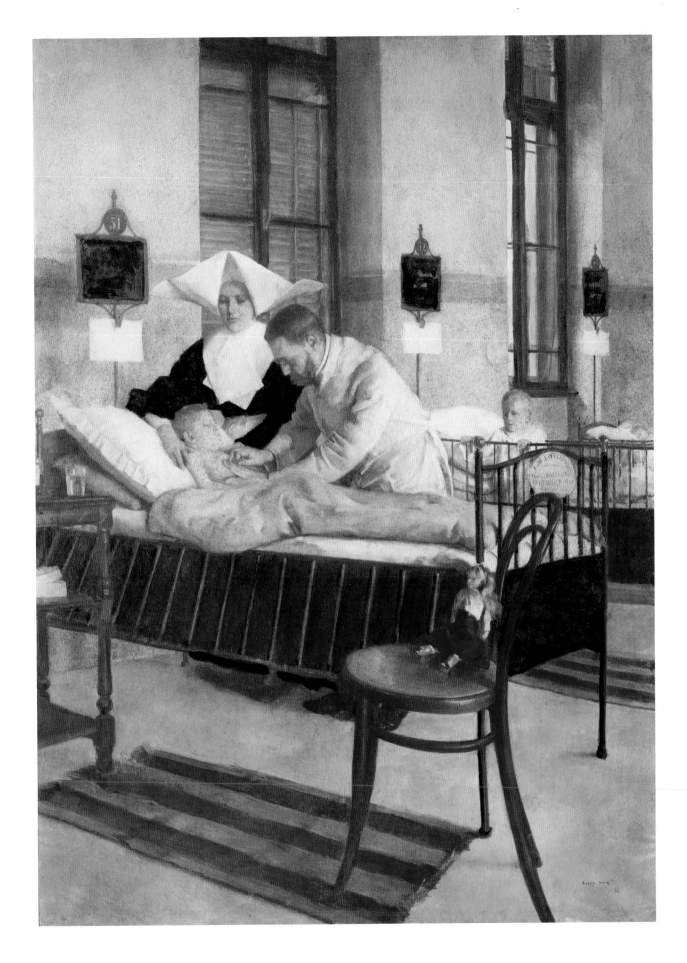

The Examination (1892), by Imre Knopp. Oil on canvas. *Location unknown.*
© Photo courtesy of akg-images, London.

48

The Same Advice I Gave Your Dad … Listerine Often (1929)

by Norman Rockwell

René Laënnec (1781–1826) introduced the stethoscope in 1819. At first, this was a simple wooden cylinder, comparable to the monaural stethoscope used even today for monitoring fetal heart sounds. For chest examination, however, this was soon replaced by the now-familiar two-ear instrument with flexible tubing introduced by the American physician George P. Cammann in 1852. Thus began a new age in diagnosis and encouraged an independent and self-reliant attitude in the doctor. Up until then, the doctor relied on taking a history, feeling the pulse and carrying out a limited examination. He now possessed an independent method for establishing a better diagnosis. Furthermore, the instrument could be fitted in the pocket and carried by the doctor on his rounds. The family doctor often visited his patients in their homes, where he was welcomed as a trusted professional. His close attention to children's ailments, often infectious diseases, particularly emphasized his role as a trusted friend.

This painting is by the American artist Norman Rockwell (1894–1978). He studied art in New York and later in Paris. Unlike many of his contemporaries, however, he remained a realist genre painter. He became best known for his covers for the popular weekly magazine, *The Saturday Evening Post*. Over 47 years, he contributed no less than 300 cover illustrations. He depicted many aspects of American life with great warmth and often humour. During World War II, many of his paintings had a patriotic theme. Later, he turned his attention to moral and racial problems in America. Until recently, he has not always found favour in the art world, being considered more an illustrator than a true artist. But ideas are changing, and a major retrospective exhibition in New York in 2002 attracted a great deal of interest and acclamation.

In this work of the early 1900s, the artist has captured the caring family doctor on one of his rounds visiting a little boy with perhaps a sore throat. His doctor's bag and his other hallmark, the stethoscope, are both evident. The dog even seems impressed. The caring doctor is still very much appreciated by families – although nowadays he or she is usually seen in the surgery rather than at home.

The Same Advice I Gave Your Dad … Listerine Often (1929) by Norman Rockwell. Oil on canvas, 78.5cm × 76cm. *New York, Pfizer Corporate Collection.*
Photo courtesy of the Norman Rockwell Museum, Stockbridge, Massachusetts.

49

Romance, Self Portrait (1920)

by Cecile Walton

Certainly by the 19th century, as practitioners became increasingly involved in home deliveries, this helped bring about a closer link between the doctor and the family. By the early 20th century in Britain, four-fifths of babies were delivered at home. But gradually the situation changed: the proportion of home deliveries began to fall to around a third in the 1950s, and to only 1 in 20 in the 1970s. In fact, nowadays very few deliveries are carried out at home. This change has reflected not only developments in fetal and maternal monitoring as well as other technologies making deliveries safer for both mother and child, but also the realization that home deliveries imposed a heavy burden on an already busy GP. Furthermore, hospital deliveries became more 'user-friendly' and more mothers chose to have their babies in hospital.

In this painting of 1920, the mother appears to have had her baby at home. The artist, Cecile Walton (1891–1956), was born in Glasgow and studied in Edinburgh, Paris and Florence. She married another artist, Eric Robertson, in 1914 and they became leading figures in an Edinburgh group of artists at the time. She herself became famous for her oil paintings. This self-portrait shows her after the birth of her second son Edward, while her first son Gavril looks on as the midwife tends her.

This very charming scene has been described as one of the few representations of birth in Western art. According to the art critic W. Gordon Smith, the work is '…in its originality, economy, colour balance, and powerful design surely one of the great Scottish paintings of the 20th century'. It has also been described as an icon of women's art.

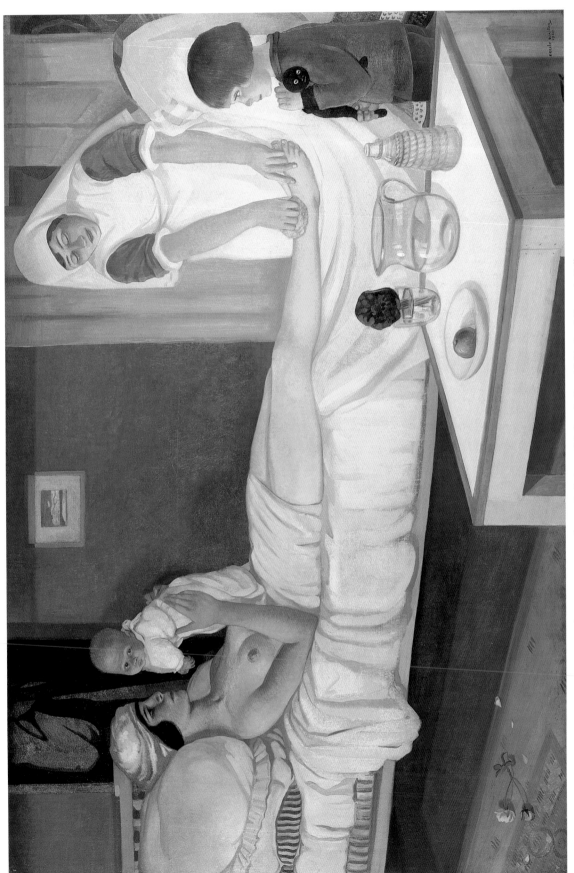

Romance, Self Portrait (1920) by Cecile Walton. Oil on canvas, 101.6 cm × 152.4 cm. *Edinburgh, Scottish National Portrait Gallery.*
© The Artist's Estate 2006.

50

An Experiment on a Bird in the Air Pump (c 1767–1768)

by Joseph Wright (called Wright of Derby)

The 18th century saw the beginnings of developments in chemistry that would have profound implications for medicine. Perhaps the most significant was Robert Boyle's (1627–1691) demonstration in 1660 that air was necessary for life and that removing air from a vacuum chamber extinguished a flame and killed small animals. Subsequently, Joseph Priestley (1733–1804) discovered and examined a variety of gases, including, most importantly, oxygen, which was necessary for life.

Several artists have been inspired by developments in science – perhaps none more than Joseph Wright (1734–1797). He was born and worked mainly in Derby, and therefore he is often known as 'Wright of Derby'. He trained in London, but returned to his home town in 1757, where he spent most of his later years and made his name as a portraitist. He often used unusual lighting effects with a single light source such as candlelight, as in this painting. He was referred to by the contemporary artist James Northcote as 'the most famous painter now living for candle-lights'. He is acknowledged as having a very firm grasp of character in his work. Here he shows the totally convincing reactions of onlookers to an experiment in which a bird loses consciousness as the air is sucked from a glass globe. The two little girls respond differently – one is clearly concerned but also interested in the outcome, while the other is too upset and turns away and is being reassured that all will be well when air is reintroduced. A young assistant prepares to lower a cage to receive the revived bird. Perhaps the moonlit night sky outside suggests more challenges for science that lie ahead. The elderly gentleman on the right, however, is lost in thought, perhaps contemplating the implications of these experiments. Incidentally, the two young lovers on the left are engrossed in each other and perhaps little concerned with science.

The latter half of the 18th century marked the beginnings of the Industrial Revolution and later the advent of many new technologies that would have profound effects on the advancement of medical science.

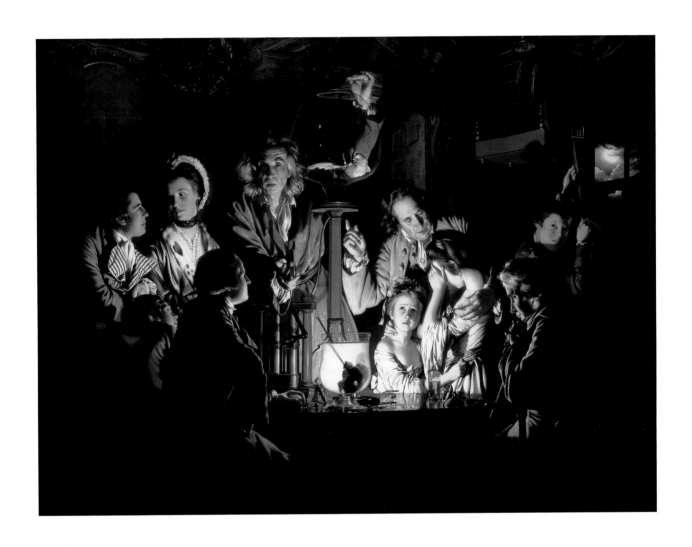

An Experiment on a Bird in the Air Pump (c 1767–1768) by Joseph Wright (called Wright of Derby). Oil on canvas, 184 cm × 243 cm. *London, National Gallery.*

51

Dr. Meryon (1850)

by John Linnell

Plaque on the site of Edward Meryon's former home at 13 Clarges Street, Piccadilly, London

by Westminster City Council

The beginnings of laboratory-based scientific medicine are not entirely clear. It had been a gradual process, but there is little doubt that many of the most important developments occurred in the 19th century. The term 'scientist' itself appears to have been first coined with its present meaning in 1840. To many medical scientists, a singularly important development at the time was microscopy. The Microscopical Society of London was formed in 1839, and one of its early Presidents was Arthur Farre FRS, who later became Professor of Midwifery at King's College. The interest in microscopy by increasing numbers of medical investigators resulted from improvements in the technology, most notably the introduction of achromatic lenses by Joseph Jackson Lister (father of the famous surgeon) in the late 1820s. Other developments included the use of clearing agents, very thin coverslips and mounting in Canada balsam, all by the mid-19th century. Among those to take particular advantage of the improved microscopy was Edward Meryon (1807–1880). He was especially interested in the childhood disease of muscular dystrophy, which, after cystic fibrosis, is the most common single-gene disorder in Western society. The disease is usually eponymously associated with the name of Duchenne, a brilliant French physician at the time. But Meryon, an English physician, described the disease several years earlier. His detailed clinical descriptions showed that it was familial and only affected boys, and that the disease was essentially of muscle, the spinal cord being normal – it was myogenic and not neurogenic in origin. Of particular interest, Meryon noted from his detailed and elegant microscopical studies that the essential defect was the breakdown of the sarcolemma. This was all reported and published in 1852, some 100 years before modern techniques confirmed the defect in the sarcolemma.

Edward Meryon was descended from Huguenot stock who immigrated to England following the Revocation of the Edict of Nantes in 1685, and several of his descendants are alive today. He studied medicine at University College London and practised mainly as a physician. He died in London on 8 November 1880 and is buried in Brompton Cemetery.

The artist of this work, John Linnell (1792–1882) was a fashionable portraitist at the time, although this is one of the last he painted, thereafter concentrating on idyllic landscapes. He was a close friend of the poet and artist William Blake, as well as of Dr. Meryon.

It may seem somewhat invidious to single out any one person in the development of medical science. The justification is that Meryon seems to have been typical of several physicians in Victorian England with enquiring minds who began to face the problems of many diseases beginning to be recognized at the time, aided by new developments in technology.

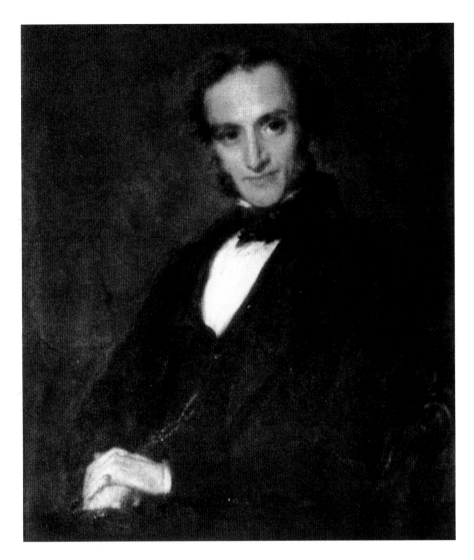

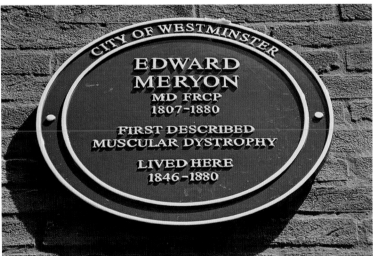

Upper figure: **Dr Meryon** (1850) by John Linnell. Oil on canvas, 184 cm × 243 cm. *Private Collection.*

Lower figure: **Plaque on the site of Edward Meryon's former home at 13 Clarges Street, Piccadilly, London**, by Westminster City Council. Metal, 45 cm diameter. *London, Clarges Street.*

52

Members of the First Clinical Faculty of Johns Hopkins, Baltimore, Maryland *or* The Four Doctors (1905)

by John Singer Sargent

The latter half of the 19th century saw major advances in medicine and surgery that led to the setting up of new medical centres with the dual aims of patient care and research. One of the most famous of these was Johns Hopkins Hospital and Medical School in Baltimore, Maryland.

This was financed by the local Quaker merchant and philanthropist Johns Hopkins (1795–1873). Its aim from its inception was to encourage original scholarship by attracting a distinguished faculty and high-calibre students. But it almost failed early on through a budget deficit that was only made good by a group of young women, including Mary Elizabeth Garrett, a wealthy Baltimore philanthropist. In return for their support, they insisted on the condition that the school should admit women. This was accepted, and the school opened as a co-educational institution in 1893, three of the twenty members of the original class being women.

Subsequently, Mary Garrett commissioned this portrait painting by the prominent American artist John Singer Sargent (1856–1924) of the four founding luminaries. Since 1929, it has hung in the Welch Medical Library at the Hospital. The artist, who worked mostly in London, struggled through the early sittings to get likenesses of his sitters as well as to express something of their different personalities. Also, the globe, seen in the centre of the group, was so large that to get it into the room the frame of the door had to be chopped away. Its importance probably relates to the roles each of the four would play in the international scene.

On the extreme left sits William Henry Welch (1850–1934), Professor of Pathology, respected scientist and highly competent organiser. He was renowned for his laboratory research and the organism *Clostridium welchii* (now called *C. perfringens*) the cause of gas gangrene, was first discovered by him. He was among those creating the new science of bacteriology and preventive medicine. Standing is William Stewart Halsted (1852–1922), Professor of Surgery, a meticulous surgeon who introduced the use of rubber gloves in surgery and pioneered radical mastectomy for breast cancer. Third from the left is William Osler (1849–1919), Professor of Medicine, a superb clinician and teacher. Several syndromes are named after him, most notably hereditary haemorrhagic telangiectasia (Osler–Rendu–Weber disease), polycythaemia vera (Osler–Vaquez disease) and Osler's nodes, painful nodular erythema in subacute bacterial endocarditis. He suggested his epitaph should read 'I taught medicine at the bedside'. The fourth person is Howard Atwood Kelly (1858–1943), Professor of Gynaecology who was a pioneer in cocaine anaesthesia and introduced several improved gynaecological surgical procedures.

With such a formidable quartet, it is hardly surprising that Johns Hopkins Hospital and Medical School became the centre of medical excellence and continues to be so today.

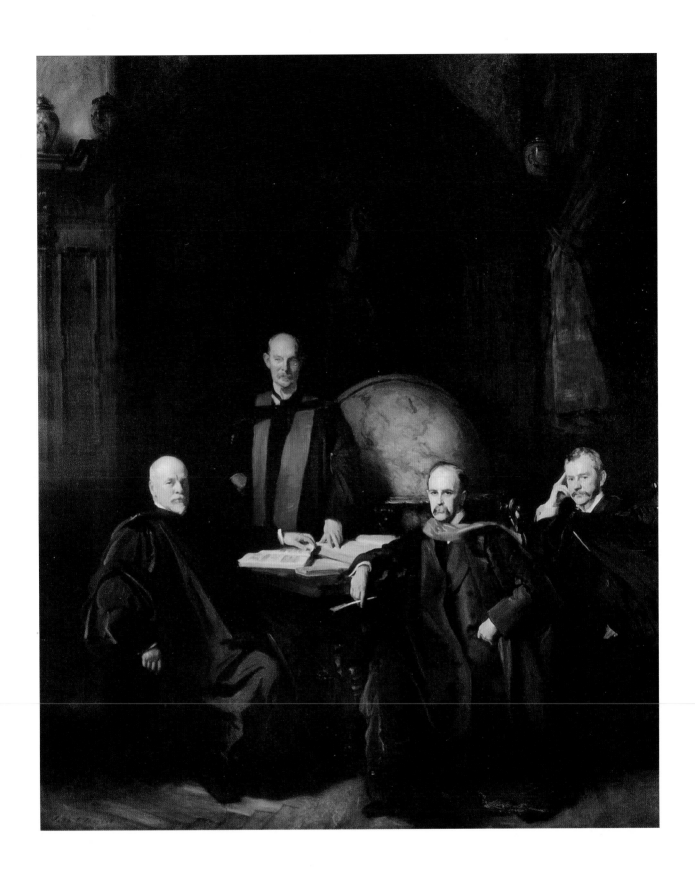

Members of the First Clinical Faculty of Johns Hopkins, Baltimore, Maryland, or ***The Four Doctors*** (1905) by John Singer Sargent.
Oil on canvas, 328 cm × 277 cm. *Baltimore, The Alan Mason Chesney Medical Archives, Johns Hopkins Medical Institutions.*

53

Quaker Doctors – True Health (1985–1991)

Panel D9 of the Quaker Tapestry

As the 20th century approached, the realization of the effects on children's health of poor housing and bad nutrition resulted in the establishment of community-based medical services. Most importantly, school medical services developed to inspect pupils and advise on dentistry, eye glasses and hearing aids, to detect cases of poor growth, rickets and tuberculosis, and to conduct vaccinations. The first full-time elementary school doctor James Kerr (1849–1911) was appointed in 1893 in Bradford, which incidentally was one of the first communities to provide school meals. School medical inspections were introduced a few years later.

Pivotal to much of the school medical service was the school nurse, who is seen here in this Quaker Tapestry, with her little patients in front of a 'tortoise' stove, common in schoolrooms of the time. In fact, many of these developments were promoted by the Quakers, or Society of Friends, who were fired by altruistic and philanthropic motives. Many Quaker doctors and their nurses were particularly concerned with preventive medicine. John Fothergill (top right) emphasized the importance of diet and exercise, Alfred Salter (bottom right) campaigned for better housing, William Tuke (bottom left) promoted humane care for the mentally ill and George Newman (centre) stressed the problems of overcrowding. Next to the School Nurse (top centre) is a mother and her baby, emblematic of the Mother and Baby Clinics established in the first half of the 20th century. The entire tapestry consists of 77 panels of embroidery celebrating some of the Quaker experiences and insights from the early beginnings in the 17th century to the present day. The Quaker Tapestry was completed between 1981 and 1996 and involved over 4000 people in 15 countries. This section was designed by Margery Levy and partly done by her and Margaretta Playfair and many Friends from East Anglia. The entire tapestry illustrates very well many of the social changes as well as major developments in medicine over the last 400 years.

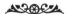

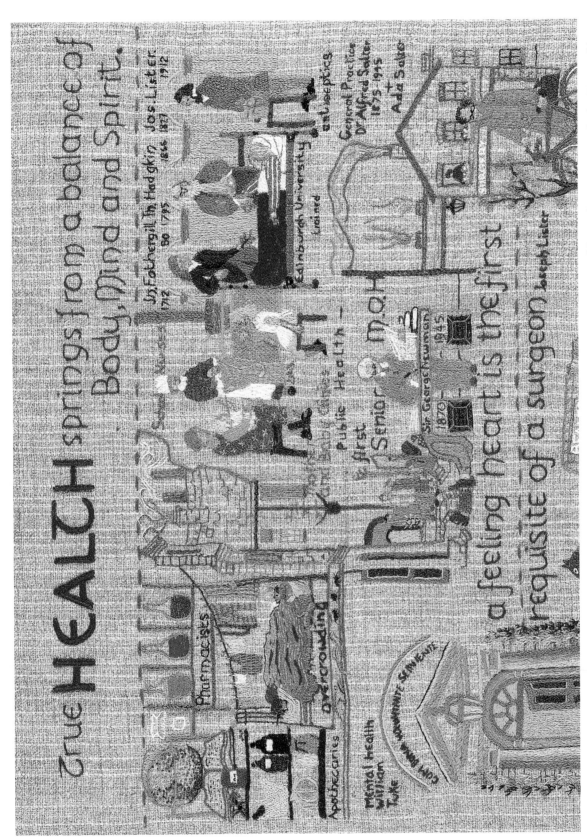

Quaker Doctors – True Health (1985–1991) Panel D9 of Quaker Tapestry. Crewel work on wool, 53.3 cm × 63.5 cm. Kendal, Friends Meeting House, Quaker Tapestry Scheme.
© Quaker Tapestry Scheme, www.quaker-tapestry.co.uk.

54

A Glasgow Close (1960)

by Joan Eardley

The artist of this work, Joan Eardley (1921–1963), was born in Warnham, Sussex, but when she was five, the family moved to London and at 17 she enrolled at Goldsmith's College of Art. However, the following year, she moved with her mother to Glasgow and continued her studies at the Glasgow School of Art, where she was awarded the Sir James Guthrie Prize for portraiture. Over the years, she was subsequently awarded many other prizes and bursaries. Apart from brief visits to Italy and France, her life centred mainly on Glasgow until, in 1952, she settled in a small cottage on the Aberdeenshire coast at Catterline. However, around 1962, she developed the first signs of breast cancer, which she tended to ignore and died the following year, the year in which she was at long last elected a full member of the Royal Scottish Academy.

In the latter period of her life, many of her paintings centre on seascapes often with menacing storm clouds and the turbulent sea. But it is her paintings of the life of deprived children in Glasgow tenements that are particularly vivid and evocative. Edwin Morgan was inspired to write a poem *To Joan Eardley*, which ends:

'I wandered by the rubble
and the houses left standing
kept a chill, dying life
in their islands of stone.
No window opened
as the coal cart rolled
and the coalman's call
fell coldly to the ground.
But the shrill children
jump on my wall.'

Poor housing, unemployment and malnutrition go hand in hand with disease. The 1980 Black Report, published as *Inequalities in Health*, showed that the poor live shorter lives and that their health in general is worse than that of the better off. Others had previously also noted that the prevalence of diseases such as tuberculosis and other infections declined more as a result of better housing and improved standards of living than from anything else.

Poor living conditions, as illustrated by Eardley in the Glasgow tenements, are gradually disappearing and increasing emphasis is now being given to education concerning smoking, dietary habits, exercise, screening and the need for preventive measures.

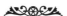

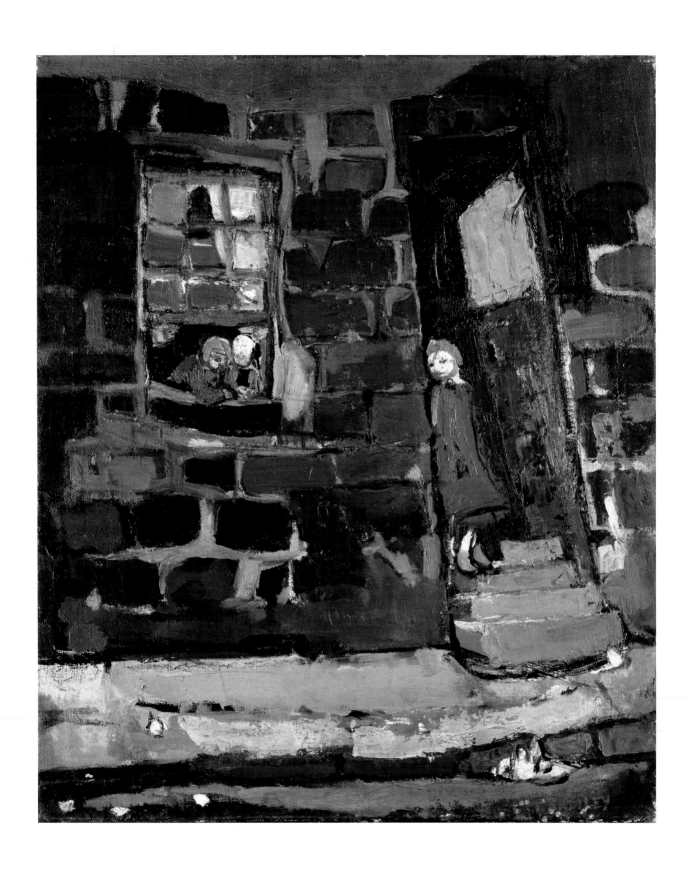

A Glasgow Close (1960) by Joan Eardley. Oil on canvas, 51.2 cm × 61 cm. *Glasgow, Hunterian Art Gallery, University of Glasgow.* Photo © By kind permission from the family estate.

55

The Death of the Mother (1889–1890)

by Edvard Munch

Thankfully, the loss of a parent by a young child is relatively rare. But the effects very often resonate throughout the rest of the child's life. Psychologists have identified a *coping process* that takes place after any serious life-event such as for example, the realization that a newborn baby has an unexpected and serious congenital abnormality, or when a child suddenly loses a loving parent. The process has been divided into five phases: *shock and denial*, *anxiety* about how to come to terms with the event, *guilt* and/or *anger* directed towards oneself or another who is imagined to be the cause, *depression*, and finally *homeostasis*. It is quite possible that the effects of a traumatic life-event, such as the death of a much-loved parent (or child), may never be fully resolved.

This painting by Edvard Munch (1863–1944) graphically illustrates a sensitive child's response to the death of its mother. She holds her hands to her ears in an attempt to 'block out' the event (*denial*). This was very relevant in the case of Munch. His mother died when he was only five, followed by his older sister, to whom he was much attached, and later his brother, all from tuberculosis. These experiences had profound effects on him, and melancholia affected him throughout most of his life. This is reflected in much of his work until, in his 40s, he underwent successful treatment with electroconvulsive therapy.

Nowadays, a prolonged period of grief might be reduced by childhood bereavement counselling by a trained professional, and of course by close and sympathetic support from the other parent. Munch's father does not seem to have been able to do this because he himself became seriously depressed and withdrawn. Other artists in the past have also suffered the lifelong effects of losing a parent in early life, but only Munch has expressed this so poignantly.

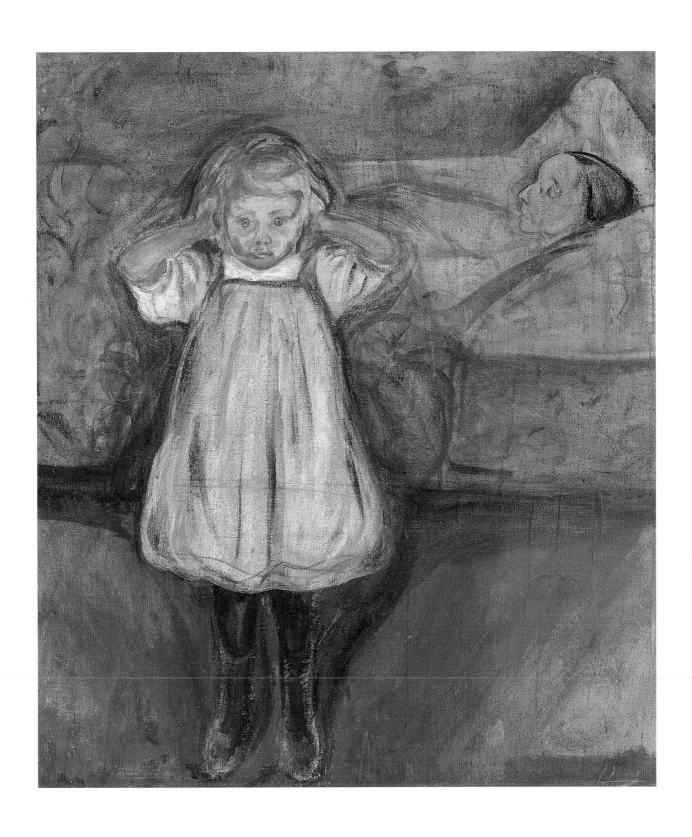

The Death of the Mother (1889–1890) by Edvard Munch. Oil on canvas, 100 cm × 90 cm. *Bremen, Kunsthalle.*
© DACS 2006.

56

Child Psychology (1933)

by Norman Rockwell

Psychiatry is a creation of the 20th century, a discipline initiated by the work of Sigmund Freud (1856–1939), the father of psychoanalysis, Alfred Adler (1870–1937), who placed inferiority at the centre of his theory of neurosis, and Carl Jung (1875–1961), who founded analytical psychology and the concepts of introversion and extroversion. In the decades following World War II, adult psychiatry was based much on the teachings of these pioneers.

Child psychiatry as a separate discipline also developed around this time, and would later become especially concerned for example with the causes and possible treatment of serious behavioural disorders such as autistic spectrum disorder (ASD) and attention deficit hyperactive disorder (ADHD). But what about behavioural problems in general and how should children be brought up normally? Some experts at the time advocated a harsh approach. For example, in the late 1920s, the American behavioural psychologist Dr John B Watson (1878–1958) advocated that parents should never hug and rarely kiss their children. 'Mother love is a dangerous instrument. An instrument which may inflict a never healing wound …' Watson's own son committed suicide. However, attitudes changed radically with the recommendations of Benjamin Spock (1903–1998), Professor of Child Development at Western Reserve University in Cleveland, Ohio, who had trained in both paediatrics and psychiatry. He emphasized a much more relaxed and caring attitude to child rearing. His book *The Common Sense Book of Baby and Child Care*, published in 1946, sold over 30 million copies and could be found in most homes in America and many in Britain.

Here Norman Rockwell illustrates in 1933 the mother's dilemma: the 'spare the rod and spoil the child' philosophy versus the new theories of child psychology being talked and written about. Spock's book was to advocate a commonsense and more reasonable approach to such matters. It gave mothers much needed reassurance, avoiding the more rigid recommendations of the past.

Spock himself was an interesting character. At Yale, he became a star oarsman and won a Gold Medal at the 1924 Olympics. He was a lifelong pacifist and later a political radical, campaigning against the Vietnam War and nuclear weapons. He ran for the US Presidency in 1972 and Vice Presidency in 1976. It may in no small measure have been that criticisms of his politics were unreasonably extended by some to his views on child rearing.

Child Psychology (1933) by Norman Rockwell. Oil on canvas, 76.2 cm × 61 cm.
Photo courtesy of the Norman Rockwell Museum, Stockbridge, Massachusetts.
Printed by kind permission of the Norman Rockwell Family Agency.
© 1933 The Norman Rockwell Family entities.

57

The Family (1988)
by Paula Rego

Paula Rego (b 1935) is a contemporary artist. She was born in Lisbon, Portugal but her talent was soon recognized by her teacher, and in 1952, aged 17, she went to study at the Slade School of Art in London. In 1959, she married the English artist Vic Willing, and for a period the couple divided their time between the two countries. But, in 1976, she settled permanently in London. This was a dark period in her life, as her husband's health was deteriorating as a result of multiple sclerosis. Nevertheless, she pursued her work and in 1983 became a visiting lecturer in painting at the Slade and in 1990 was appointed the first National Gallery Associate Artist in Residence. She has gone on to international acclaim and has held many exhibitions and been awarded several honorary doctorates both in Britain and abroad. In 2005, she was commissioned by the Royal Mail to produce a set of Jane Eyre stamps.

Her later works are painted in a flat style, often telling a story with psychosexual undertones. This work is in many ways typical. The absent father has returned home, but his wife and daughter are manhandling him in an odd way. The daughter seems actually to confront him. The bed is unmade. What of the little girl by the window who seems expectant of something? Are there clues in the picture of St Joan and St George slaying the dragon? What is the significance of the discarded rose? Other artists who have been drawn to psychosexual themes include Balthus (1908–2001) and recently the Scottish artist Steven Campbell (b 1953).

The Oedipus and Electra complexes were ideas developed by Freud and Jung based on Greek mythology. Put simply, Oedipus unknowingly married his mother Jocasta, and Electra grieved deeply for her father Agamemnon, slain by her mother. Anna Freud (1895–1982), a daughter of Sigmund Freud, believed that during adolescence psychosexual and emotional changes could engender these complexes. She argued that 'disharmony within the psychic structure' was a basic fact of adolescence resulting in alienation from a parent. However, careful studies of adolescents have now shown such ideas to be very much an oversimplification. Nevertheless, within families, an adolescent's overly close relationship with a parent may well engender jealousy and alienation in the other parent. Paula Rego seems to examine such matters in a fascinating, even troubling, way.

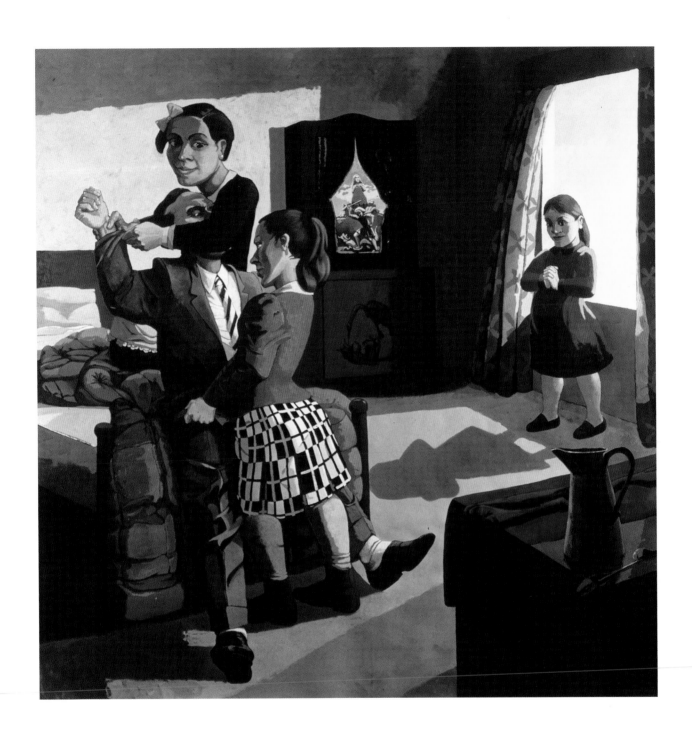

The Family (1988) by Paula Rego. Acrylic on paper mounted on canvas, 213.4 cm × 213.4 cm. *London, Saatchi Collection.*
© The Saatchi Gallery.

58

'Incubators' at the Maternity Hospital, Port Royal, Paris (1884)

by Eugène Froment, from the Illustrated London News

This wood engraving from the *Illustrated London News* of 1884 depicts several early incubators. The engraver was Eugène Froment (1844–1900), a French artist and engraver who moved to London and became a leading illustrator. It was his fellow-countryman Étienne Stéphane Tarnier (1828–1897) who is usually credited with the idea of an incubator for saving the lives of premature or weak newborn babies. The idea came to him after seeing equipment used for incubating hen's eggs and given the name *couveuse* (French for a broody hen, *couveuse artificielle* for an incubator of eggs and young chicks). The first was introduced into the Paris Maternity Hospital in 1880 and consisted essentially of a heated and ventilated box to hold one or two babies. It had double walls, with the space between them being filled with hot water. The improvement in mortality rates among premature babies was dramatic. Before the introduction of the *couveuse,* over a third of premature babies died; a year after its introduction, the mortality fell to less than one in 10. With ever improving technology, and despite the increasing prematurity of the treated babies, the mortality rate continued to fall. These improvements included electrical heating of the water jacket with thermostatic control, and moistening and filtering the air intake.

Along with these developments emerged the speciality of neonatology, requiring considerable expertise from neonatal paediatricians and the support of specially trained and dedicated nurses. In Britain, the first full-time neonatologist was appointed in 1959, although similar developments had taken place in Europe earlier, and the following year saw the introduction of umbilical catheterization and safe techniques for administering oxygen where necessary. Aggressive oxygen therapy introduced in the 1940s had been shown to cause retrolental fibroplasia and is now very carefully controlled, with blood gases being continually monitored using appropriate safety alarms. Incubators now also incorporate ports for manual access and for various tubing.

The modern premature baby unit with its array of sophisticated equipment and quiet atmosphere with professionally trained staff is very different from the artist's depicted scene of 1880.

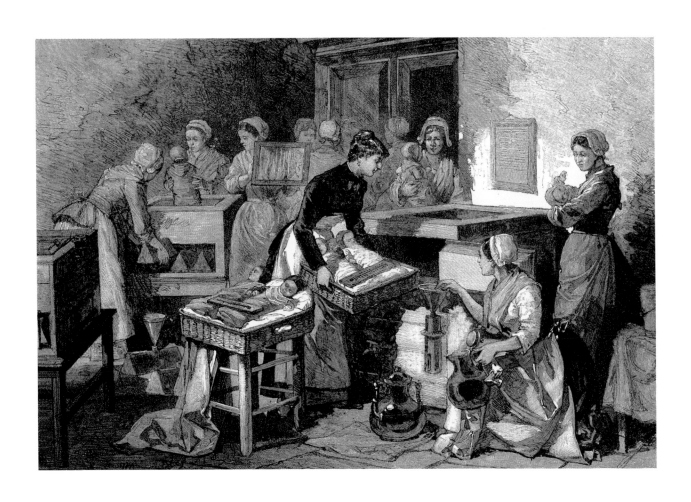

'Incubators' at the Maternity Hospital, Port Royal, Paris (1884) by Eugène Froment from the *Illustrated London News*. Wood engraving, 21.6 cm × 30.5 cm. *London, The Illustrated London News Picture Library.*

59

The Fetus (c 1905)

by Gustav-Adolf Mossa

Gustav-Adolf Mossa (1883–1971) was born in Nice, where the Art Gallery has many of his works on display. He showed an early talent for painting and was encouraged and taught in part by his father Alexis Mossa (1844–1926), who was also an artist. He became much influenced by the Symbolist movement at the time, a reaction against both Impressionism and Realism, the idea being to suggest and evoke feelings in the viewer rather than being too explicit. Here, for example, a well-dressed sophisticated couple are leaving for some function. But the scene is dominated by a fetus in an elaborate glass case on a table with withering flowers. Is this to imply that an abortion was carried out because the couple are not married? Alternatively, is it because pregnancy and a child would have been too inconvenient and interfere too much with their fashionable lifestyle? As they prepare for their evening's social engagement, they seem indifferent to the gruesome object in the glass case on the marble table in their dressing room.

Until the Abortion Act came into force in 1967, a 'therapeutic abortion' was only legal if the mother's health or life was in great danger, and there were relatively few of these cases. Far more illegal abortions were carried out by 'back-street abortionists', often with dire consequences for both mother and baby. With the Act, implemented the following year, other indications were included – for example, if there was a risk to the life or health of the pregnant mother or to her existing children, or if there was a risk that the child might suffer serious mental or physical handicap. Of the 185 400 abortions carried out in England and Wales in 2004, the greatest number were in women aged between 18 and 24 years of age, mostly before 13 weeks' gestation, and very few because of the risk of the child being born handicapped. It seems likely that many of these pregnancies were the result of unprotected sex or failed contraception. Perhaps this was the case in Mossa's enigmatic painting.

The Fetus (c 1905) by Gustav-Adolf Mossa. Watercolour and gouache on paper, 34 cm × 19 cm. *Nice, musée des Beaux-Arts Jules Chéret.*
© ADAGP, Paris and DACS, London 2006.

60

A Cornucopia of Contraception, Ancient and Modern (1984)

The Intrauterine Device Collection (nd)

artefacts assembled by Percy Skuy

These displays from an exhibition in Cleveland, Ohio demonstrate very clearly what Malcolm Potts and Roger Short have referred to in their book *Ever Since Adam and Eve* (Cambridge University Press, 1999) as a cornucopia of contraceptive methods. They were assembled over the last 40 years by Percy Skuy, past President of Ortho Pharmaceutical (Canada), who arranged for his collection to be donated to Case Western Reserve University, where it is housed in the Dittrick Medical History Center.

Contraception in Ancient Egypt included recommendations that various materials and extracts should be placed in the vagina. Many of these preparations included honey, which, through its osmotic effect, may have been spermicidal. But there is also a suspicion that some of the ingredients might have been intended to deter the partner! In Greece, similar methods were advocated, and if all else failed abortion could be resorted to.

Although condoms from animal intestines were used in Hogarth's time, it was the rubber condom and, from the 1930s, the latex sheath that proved far more acceptable. Similarly, diaphragms, cervical caps, and spermicides all became more reliable from the 1950s. The intrauterine device (IUD) became particularly favoured by many women at around the same time. These were variously made from silkworm gut, metal and finally polyethylene, which proved best, and they were produced in different shapes and sizes, one of the most popular in Britain being Lippes' loop. But they have to be inserted by a professional and there can be side-effects such as bleeding and infection. Nevertheless they are of value where oral contraception is unacceptable or there is poor motivation.

The introduction of oral contraceptives – 'the Pill' – was a major step forward pioneered by the research scientists Gregory Pincus and his colleague Min-Cheuh Chang, and the clinicians John Rock and Ramon Garcia. Their work led to the first available contraceptive pill in 1960. Thereafter, improvements led to ultra-low-dose pills, implantable products and now 'the morning-after pill'. Injectable hormonal products for male contraception are also being developed.

The need for an awareness of contraception among women led to the establishment of family planning clinics, first by Margaret Sanger in America and later by Marie Stopes in England in 1921. The International Planned Parenthood Federation (IPPF) was founded in 1952 and has expanded its world-wide programmes ever since.

Funding for male condoms in developing countries where HIV/AIDS is common is being fiercely debated, with certain religious and political groups being very much opposed to the idea. Others are more sympathetic, believing that this may help reduce the incidence of the disease.

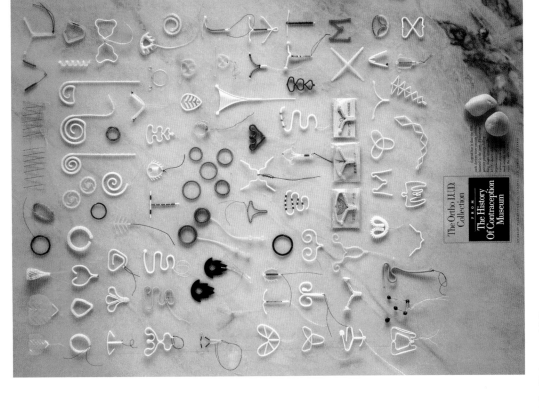

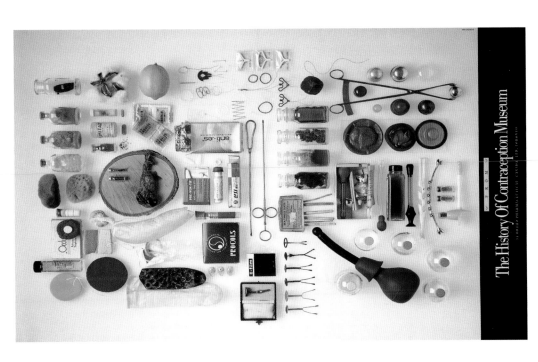

Left figure: *A Cornucopia of Contraception, Ancient and Modern* (1984). 62.9 cm × 44.5 cm.

Right figure: *The Intrauterine Device Collection* (nd). 62.9 cm × 44.5 cm.

Artefacts assembled by Percy Skuy. Cleveland, Ohio, The Percy Skuy Collection on the History of Contraception, Dittrick Medical History Center, Case Western Reserve University.

61

Child After a Liver Transplant (1989)

by Sir Roy Calne

A few practising physicians have also been renowned artists, a notable example being Georges-Alexandre Chicotot, who was Head of Radiotherapy at the Hôpital Broca in Paris in the early 20th century. However, there have been several surgeons who also became well known for their art, most notably in recent times Sir Roy Calne (b 1930). He is a retired Professor of Surgery at the University of Cambridge and one of the first pioneers in organ transplantation using drugs to suppress graft rejection.

He began painting at an early age, but in 1988 he met the Scottish artist John Bellany (b 1942), who was desperately ill with liver disease. Bellany is perhaps best known for his dramatic compositions, often featuring the life and work of fishermen from his early home on the east coast of Scotland. Sir Roy Calne performed a liver transplant on him, and soon after Bellany recovered, he painted a dramatic and disturbing work, *Prometheus*, with clear connotations. Thereafter, some critics say Bellany's work became more lyrical, but this is not apparent in at least some works such as *The Bride*, exhibited at the Royal Scottish Academy in 2004.

Whatever the effect surgery had on Bellany, the artist had a significant effect on Calne's painting, advising him to loosen his style and use brighter colours.

In 1989, Calne produced two noted paintings of patients recovering from a liver transplant: one of a teenage boy and this one of a little girl. His concern with the feelings of his patients is clearly evident in these paintings, as well as in many others. Here he has captured the little girl's vulnerability, with her hands clasped and her legs drawn together, gazing rather fearfully sideways at the artist. He has reduced the image to mere essentials, concentrating on those aspects that most vividly and tellingly illustrate the little girl's predicament.

Severe liver disease in children had a very poor prognosis until liver transplantation became a real possibility, the first in Europe being performed by Calne in 1968 just 20 years before this painting, and patients can now survive well into adulthood.

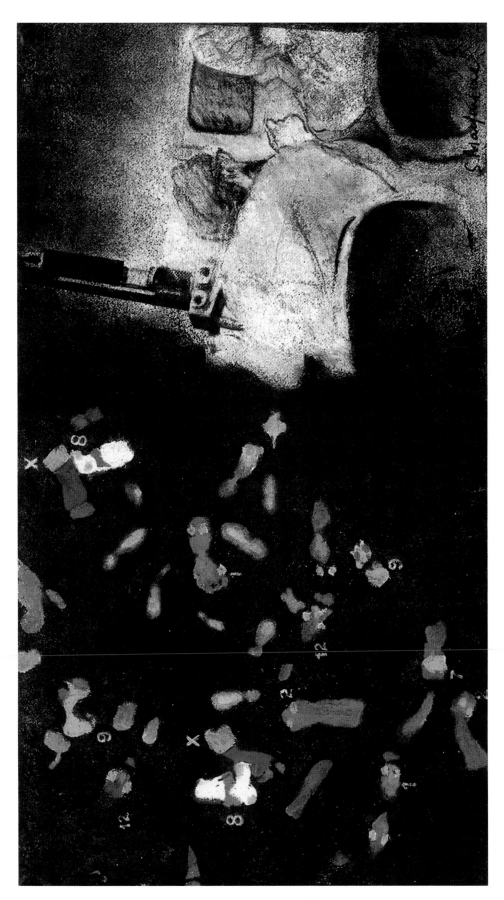

Cytogenetics: A Lesson on Typing the Chromosomes (1996–1997) by Susan Macfarlane. Oil on canvas, 25 cm × 45.5 cm. *High Wycombe, Buckinghamshire, A Picture of Health Ltd.*
Reproduced by kind permission of Mr Euan and Mr Angus Mackay.

64

Bathsheba with King David's Letter (1654)
by Rembrandt van Rijn

In this painting, Rembrandt van Rijn (1606–1669), the greatest of all Dutch artists, has depicted his mistress Hendrickje Stoffels as Bathsheba. It has been suggested that the lump in the upper quadrant of her left breast indicates that she had breast cancer. But, although useful for teaching purposes, the diagnosis seems most unlikely, because she died nine years after the work had been completed. In October of the same year, she gave birth to their daughter, and the abnormality may more likely have been related to an infection during breastfeeding. Incidentally, it was in the same year that Hendrickje was summoned to appear before the Council of the Reformed Congregation for 'practising whoredom with the painter Rembrandt'.

'Much of today's surgery is concerned with the treatment of benign and malignant tumours. Indeed much of surgical history, especially in the past 100 years or so, is concerned with the development of techniques for the removal of organs affected by these diseases'. Thus wrote Harold Ellis, the distinguished surgeon, in his recent history of the speciality, *A History of Surgery*, (Greenwich Medical Media Ltd., 2001).

Diseases of the breast have been recorded by doctors from earliest times, and even Hippocrates is quoted as drawing attention to breast cancer in a woman from Abdera, a Greek city on the coast of Thrace. The treatment of breast cancer has advanced considerably in recent years. Halsted's recommended radical mastectomy is nowadays rarely necessary. Early diagnosis, with mammography and breast screening, has resulted in less need for major surgery and has led to a significantly better prognosis. Instead, far more conservative operations are advocated, followed, where necessary, by radiotherapy and chemotherapy.

Researchers are now also turning their attention to the identification of drugs that may arrest or slow the disease process at an early stage. Coupled with this are molecular biological investigations aimed at identifying those women most likely to benefit from such drugs. For example, in the case of oestrogen receptor-positive tumours, the drug tamoxifen and more recently the aromatase inhibitors are proving beneficial. Latest research indicates that those patients in whom the cancer cells overexpress human epidermal growth factor receptor 2 (HER2) can benefit from the drug trastuzumab (Herceptin). Many other approaches to drug therapy are now currently being explored.

In the entire history of breast cancer, there has never been a time when research has improved the prognosis more than today.

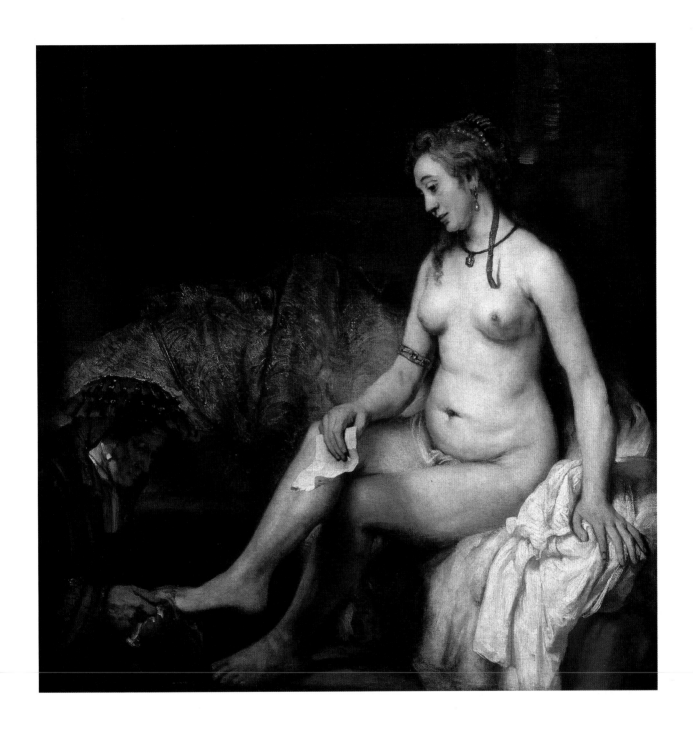

Bathsheba with King David's Letter (1654) by Rembrandt van Rijn. Oil on canvas, 142 cm × 142 cm. *Paris, musée du Louvre.*
© Photo RMN/© Hervé Lewandowski.

65

Just What Is It That Makes Today's Homes So Different, So Appealing? (1956)

by Richard Hamilton

The most prominent feature in this collage is the word 'Pop'. The work was completed in 1956 and was one of the earliest in a new movement in British and American art referred to as *Pop Art*. The movement was so-called because it drew its inspiration, imagery and materials from popular mass culture. Richard Hamilton (b 1922) was one of the very earliest exponents of Pop Art, which attracted the attention of many other artists. In Britain these included, among others, Peter Blake (b 1932) and David Hockney (b 1937).

Hamilton took art classes when he was 12, but left school at 14 for a job in an engineering firm and then at 16 became a student at the Royal Academy Schools. During the war, he worked as a draughtsman, returning to the Royal Academy afterwards only to be expelled 'for not profiting from the instruction...'. Nevertheless, he continued with his art studies, and interestingly in 1951 conceived an exhibition 'Growth and Form' inspired by D'Arcy Thompson's celebrated work on quantitative biology of the same title published in 1917. Since then, his work has increasingly attracted national and international attention, with numerous exhibitions. He is now well into his eighties and continues to be as active as ever.

This work is an icon of Pop Art. It is full of postwar images centring on the modern home, with symbols of contemporary mass media, popular culture and advertising. The lady of the house on the one hand is beautifying and making herself attractive, even seductive, and on the other hand is vacuuming the stairs. The wife was then considered very much a homemaker involved in domestic matters and caring for her family. However, in recent years, the woman's role has changed considerably. She is now often working, perhaps in a professional capacity. Office of National Statistics data show that in recent years more women are choosing to live alone or cohabit. Marriage rates have fallen and divorce rates have risen, with the number of single-parent families also increasing. Many of society's problems today have been attributed to the breakdown of the home and a decrease in stable partnerships. Did Richard Hamilton foresee these changes 50 years ago when he produced this collage? One suspects that he did not, but he did identify many of the aspects of modern home life then that were to have significant effects in the future.

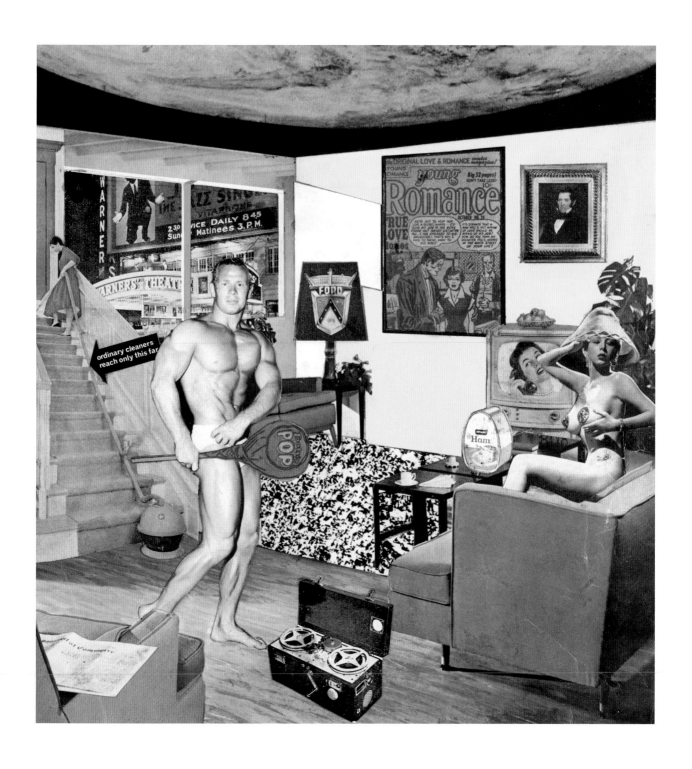

Just What is it That Makes Today's Homes So Different, So Appealing? (1956) by Richard Hamilton. Collage on paper, 26 cm × 25 cm. *Tübingen, Germany, Kunsthalle.*

66

Eugenia Martinez Vallejo, La Monstrua (c 1680)
by Juan Carreño de Miranda

The artist of this work, Juan Carreño de Miranda (1614–1685), was the most important Spanish Court Painter after Velazquez. He was a nobleman by birth, and was appointed Painter to the King in 1669 and Court Painter in 1671. He painted several religious works, but is perhaps best known for his elegant portraits of members of the Royal Court. Like Velazquez's perceptive paintings of the many dwarfs in the Court, Carreño's portraits are also detailed and revealing.

The child in this work was aged five at the time, and Carreño also painted her fully clothed. The title, *La Monstrua*, nowadays would not be considered in good taste, but this was clearly not so in 17th century Spain. A number of medical geneticists think that she may have had Prader-Willi syndrome, which is characterized by, for example, obesity, mental handicap, small hands and feet, diabetes, and hypogonadism. This syndrome is known to be due to a defect in a paternally derived chromosome 15.

Whatever the nature of this little girl's affliction, she is certainly obese. But genetic causes of obesity are rare, and the majority of cases result from an inappropriate diet and lack of physical activity – both factors stemming from lifestyle and behavioural changes in recent years. In fact, in Britain, childhood obesity has reached epidemic proportions. In 2- to 10-year-olds in Britain, the proportion of obese children rose from 9.9% to 13.7% between 1995 and 2003. Obesity predisposes to diabetes, hypertension and cardiovascular disease in later life, and it has been predicted that if the present trend continues, the next generation will have a shorter life-expectancy than their parents. Furthermore, obesity is also affecting the adult population, including of course parents, where additional factors such as stress at home and work may play a part.

The reduction, and hopefully eradication, of obesity in both children and adults is a serious challenge, attracting much attention today from several professional bodies – a problem that only a few decades ago would have been almost unimaginable.

Eugenia Martinez Vallejo, La Monstrua (c 1680) by Juan Carreño de Miranda. Oil on canvas, 165 cm × 107 cm. *Madrid, Museo Nacional del Prado.*

67

Medical Genetics in the Prevention of Handicap (1983)

by Timothy Chalk, Paul Grime, David Wilkinson (Artist's Collective)

The elucidation of the helical structure of DNA by James Watson and Francis Crick in 1953 led to ramifications and developments in medical science that few would have foretold at the time. Our subsequent understanding of the structure and function of genes and their role in pathogenesis has had an enormous impact on almost all branches of medicine and surgery. There was also the emergence of Medical Genetics as a new speciality largely through the efforts of J. A. Fraser Roberts, Cedric Carter and Paul Polani in London. The first Departments outside London were set up in Manchester and Edinburgh in the 1960s. There are now similar Departments throughout the country where the main aim is to provide genetic counselling for a variety of inherited conditions.

The Human Genome Project was completed in April 2003 with the sequencing of the entire genome of some 3 billion base pairs (3×10^9). We now know there are around 25 000 protein-coding genes. Over 14 000 single-gene disorders have also been identified, and well over a thousand of the genes responsible have been cloned and studied in detail. These developments are leading to improvements in diagnosis as well as prevention through prenatal diagnosis. The hope is also that with various novel strategies, such as gene therapy through gene replacement, there may emerge effective treatments for certain of these single-gene disorders.

In most common diseases, however, many genes plus the effects of environmental factors are believed to be causative. By identifying such predisposing genes or DNA sequences, it is hoped this information may provide clues for more effective treatments. There are already instances where this is true. Some of these developments are featured in this mural by local artists commissioned by the Department of Medical Genetics in Glasgow.

Along with all these developments, however, have emerged a number of serious ethical problems – for example, the importance of maintaining confidentiality of information about affected individuals and their families, problems of insurance for those found to be at risk of a serious life-threatening disorder (although there is currently an agreed moratorium on the use of such tests for insurance purposes until 2011), and the ethical problems raised by patenting of DNA sequences used in diagnosis.

Perhaps this is a time to pause and consider the implications of all these developments, particularly in regard to common diseases. Trisha Greenhalgh, Professor of Primary Health Care at University College London, has recently written '…we must disabuse the public and ourselves of the notion that whatever the medical question, genetic information will provide the answer'. Many other factors are also involved in *causing* most common diseases, not the least of these being the environment and our different lifestyles. It seems that although genetics will continue to play a very important role in the management of single-gene disorders, other factors must be considered as well in many common diseases. Their elucidation may lead to simpler more direct means of prevention.

Medical Genetics in the Prevention of Handicap (1983) by Timothy Chalk, Paul Grime, David Wilkinson (Artist's Collective). Acrylic on plywood, 152 cm × 340 cm. *Glasgow, Duncan Guthrie Institute.*

A Selection of Works of Art Depicting Mother and Child Care

(excluding those paintings described in the text)

SUBJECT	PAINTING Title (date)	Location	ARTIST
Alcohol/intemperance	A Woman Drinking with Two Gentlemen (1658)	Paris, Louvre	Pieter de Hooch (1629–1684)
	Woman Drinking Wine with a Sleeping Soldier (early 1660s)	Private collection	Gerard ter Borch (1617–1681)
	Beer Street (1750–1751)	London, British Museum	William Hogarth (1697–1764)
	Gin Lane (1750–1751)	London, British Museum	William Hogarth (1697–1764)
	Absinthe (c 1876)	Paris, musée d'Orsay	Edgar Degas (1834–1917)
Breast cancer	La Fornarina (c 1620)	Rome, Galleria Nazionale d'Arte Antica – Palazzo Barberini	Raphael (1483–1520)
	Vanitas: the Allegory of Evanescence (c 1626)	Esztergom, Hungary, Christian Museum	Nicholas Régnier (1591–1667) or Johann Liss (1593–1667)
	Hilda (nd)	The Walston Collection	Sir Stanley Spencer (1891–1959)
	The First Trial of X-Ray Therapy for Cancer of the Breast (1907–1908)	Paris, musée de l'Assistance Publique	Georges-Alexandre Chicotot (fl 1880–1911)
	A Picture of Health: Paintings and Drawings of Breast Cancer Care (1991–1995)	High Wycombe, England, A Picture of Health Ltd, Travelling Exhibition	Susan Macfarlane (1938–2002)
Breastfeeding	Relief of Woman and Child (c 690–650 BC)	Thebes, Tomb of Montuemhat	Anonymous sculptor
	St. Luke Drawing the Virgin (c 1450)	Munich, Alte Pinakothek	Rogier van der Weyden (1399/1400–1464)
	Woman Nursing an Infant, with a Child Feeding a Dog (1658–1660)	San Francisco, Fine Arts Museum	Pieter de Hooch (1629–c 1683)
	The Young Mother (c 1660)	Berlin, Gemäldegalerie	Gerrit Dou (1613–1675)
	Visit to the Child at Nurse (c 1788)	Cambridge, Fitzwilliam Museum	George Morland (1763–1804)
	The Lightning Bolt (1848)	Paris, musée d'Orsay	Alexandre Antigna (1817–1878)
	Summer (1873)	Paris, musée d'Orsay	Pierre Puvis de Chavannes (1824–1898)
	Mother and Child (1892)	Edinburgh, National Gallery of Scotland	Pierre-August Renoir (1841–1919)
	Maternity (1905)	Paris, Private Collection	Pablo Picasso (1881–1973)
	Mother (1893)	Helsinki, Finnish National Gallery Ateneum	Elin Danielson-Gambogi (1861–1919)
	Mother and Child (1902)	St Petersburg, Russian State Museum	Aleksandr Viktorovich Moravov (1878–1951)
	Nursing Mother (c 1902)	Berlin, Galerie Michael Haas	Paula Modersohn-Becker (1876–1907)
	The Drop of Milk in Belleville: Doctor Variot's Surgery, The Consultation (1903)	Paris, musée del'Assistance Publique	Henri Geoffroy (1853–1924)
Children in hospital	The Christmas Story in the Children's Hospital (wood engraving from the Illustrated London News) (1881)	London, British Library	Henry R. Robertson (1839–1919)
	The Children's Hospital (wood engraving from The Illustrated London News) (1882)	London, British Library	W. I. Mosses (after a painting by Thomas Davidson) (fl 1863–1903)
	Boy After a Liver Transplant (1989)	Artist's Collection	Sir Roy Calne (b 1930)
Children's doctor	Tombstone of the athenian Physician Jason (2nd century BC)	London, British Museum	Anonymous, Greek sculptural bas-relief
	Physician Touches Stomach of Child (12th century manuscript of the Pseudo-Apuleius Herbal)	Florence, Biblioteca Laurenziana, MS Plut. 73.16, f 29v	Anonymous
	The Sick Room (1864)	London, Foundling Museum	Emma Brownlow (fl 1852–1867)
	The Doctor (c 1891)	London, Tate Britain	Sir Luke Fildes (1843–1927)
	The Good Samaritan (1899)	Leicester, New Walk Museum	William Small (1843–1929)

SUBJECT	PAINTING Title (date)	Location	ARTIST
Nursing (contd.)	*Child with Nurse* (nd)	St Petersburg, Hermitage	Pietro Marescalca (Lo Spada) (c 1503–1584)
	The Sisters of Charity of Antwerp Nursing the Sick (nd)	Antwerp, Belgium, Koninklijk Museum voor Schone Kunsten	Jacob Jordaens (1593–1678)
	The Sister of Mercy (c 1830)	London, Wallace Collection	Ary Scheffer (1795–1858)
Pregnancy	*Maternal Caress* (etching, 1891)	New York, Metropolitan Museum	Mary Cassatt (1844–1926)
	Maternity (1924)	Private Collection	Juan Miró (1893–1983)
	Pregnant Woman in Blue (1992)	Private Collection	Robin Granger-Taylor (b 1963)
	Pregnant Woman (sculpture, 2002)	Canberra, National Gallery of Australia	Ron Mueck (b 1958)
Psychological matters	*Girl and Cat* (1937)	Private Collection	Balthus (Count Balthasar Klossowski de Rola) (b 1908)
Swaddling (see also Multiple births)	*The Adoration of the Shepherds* (c 1640s)	London, Wallace Collection	Philippe de Champaigne (1602–1674)
	Celebrating the Birth (The Christening Feast) (1664)	London, Wallace Collection	Jan Steen (1626/27–1679)
Teaching	*The Reading Lesson* (nd)	Paris, Louvre	Gerard ter Borch (1617–1681)
	A School for Boys and Girls (The Unruly School) (nd)	Edinburgh, National Gallery of Scotland	Jan Steen (1626/27–1679)
	The Schoolmaster (c 1663–1665) *The Young Schoolmistress* (c 1736–1737)	Dublin, National Gallery of Ireland London, National Gallery	Jan Steen (c 1626–1679) Jean-Baptiste-Siméon Chardin (1699–1779)
	The Schoolmistress or *'Say Please'* (c 1780)	London, Wallace Collection	Jean-Honoré Fragonard (1732–1806)
	The Village School (c 1826)	Edinburgh, National Gallery of Scotland	Sir George Harvey (1806–1876)
	A Schule Skailin' (1846)	Edinburgh, National Gallery of Scotland	Sir George Harvey (1806–1876)
	A Child Learning to Read (c 1850)	London, Wallace Collection	Hippolyte (Paul) Delaroche (1797–1856)
	The Poor Schoolboy (1876)	Paris, musée d'Orsay	Antonio Mancini (1852–1930)
Vaccination	*Vaccination* (1807)	London, Wellcome Library	Louis-Léopold Boilly (1761–1845)
	The Cow-Pock-or-The Wonderful Effects of the New Inoculation of Edward Jenner (c 1801–1812)	London, British Museum	James Gillray (1757–1815)
	Baron Jean Louis Albert (1768–1827) Performing the Vaccination Against Smallpox in the Château of Liancourt in the Oise (c 1820)	Paris, musée de l'Assistance Publique	Constant Joseph Desbordes (1761–1827)
	Vaccination Clinic in Germany (1857)	Berlin, Bildarchiv Preussischer Kulturbesitz	Reinhard Sebastian Zimmerman (1815–1893)
	Vaccination (c 1901)	London, Wellcome Library	Lance Calkin (1859–1936)
	La Vaccination (process print, 1905)	London, Wellcome Library	After a painting by Pascale-Adolphe-Jean Dagnan-Bouveret (1852–1929)
	Serum Therapy (c 1896)	Philadelphia, Museum of Art	Charles Maurin (1856–1914)
	Vaccination: Dr Jenner Performing his First Vaccination, 1796 (nd)	London, Wellcome Library	Ernest Board (1877–1934)
	La Vacuna (1931)	Detroit, Detroit Museum	Diego Rivera (1886–1957)
	Vaccination (1935) (wood engraving)	?Mexico City	Leopoldo Méndez (1902–1969)